MADE IN MIND

NON

OBJECT

NONOBJECT

Branko Lukić with text by Barry M. Kātz

foreword by Bill Moggridge

The MIT Press

Cambridge, Massachusetts

London, England

For information about special quantity discounts, please e-mail special_sales@mitpress.mit.edu

This book was set in Celeste and Helvetica Neue by Nonobject. Printed in Spain.

Library of Congress Cataloging-in-Publication Data

Lukić, Branko.

 Nonobject / Branko Lukić ; with text by Barry M. Kātz ; foreword by Bill Moggridge.

 p. cm.

ISBN 978-0-262-01484-7 (hardcover : alk. paper) 1. Design—Philosophy. 2. Design—Psychological aspects. 3. Consumer goods—Psychological aspects. I. Kātz, Barry, 1950— II. Title.

NK1505.L85 2010

745.5—dc22

 2010013316

10 9 8 7 6 5 4 3 2 1

Credits

Book designed by Nonobject

3D modeling and CG by Nonobject and Marko Milanković

Drawings on page 73 by Nebojša Rogić

Photography by Nonobject

Photography used on pages 20, 41, 82, 158, and 190 by Nebojša Babić

Selected renderings done with Bunkspeed Move software

Contents

ACKNOWLEDGMENTS

THANK YOU TO:

MATIJA AND MAKSIM; LJUBIŠA AND JOVANKA LUKIĆ; MILAN LUKIĆ; RANKO AND RADMILA MANDIĆ; STEVEN TAKAYAMA; MARKO MILANKOVIĆ; NEBOJŠA BABIĆ; SINIŠA ROGIĆ, MILOŠ VUKIČEVIĆ, AND SHMI OF INBOX-ONLINE; IVANA OGNJANOVIĆ AND GORAN SIMONOSKI; ALEKSANDRA AND JOVANA OF ORANGE STUDIO; NEBOJŠA ROGIĆ; VOJIN DJORDJEVIĆ; BILL MOGGRIDGE; DEJAN PUTNIK; MAUREEN SPITZ; URI TZARNOTZKY; BESSY LIANG; PENNY NELSON; PAVEL GUBIN; DARIN WHITE OF BUNKSPEED; DONN KOH; JENNIFER LEONARD; NICOLÒ CECCARELLI AND PETAR JO-VOVIC. THEY PROVIDED UNWAVERING MORAL SUPPORT AND UNEQUALED TECHNICAL GENIUS.

THANK YOU TOO:

SENIOR EDITOR DOUGLAS SERY AND THE TEAM AT THE MIT PRESS, INCLUDING ASTRID BAEHRECKE, JUDITH BUL-LENT, ANNE BUNN, SUSAN CLARK, TOM CLERKIN, JOHN COSTELLO, DIANE DENNER, RUTH HARRIS, ALLISON POTTERN HOCH, KATIE HOPE, YASUYO IGUCHI, JOHN JENKINS, THERESA M. LAMOUREUX, COLLEEN LANICK, SANDRA MINKKINEN, MICHELLE PULLANO, PAMELA QUICK, ABBY STREETER ROAKE, CHRISTINA SANMARTIN, KATY SATO-PAPAGIANNIS, VINCENT SCORZIELLO, ANN SEXSMITH, KELLEY TRAVERS, ANN TWISELTON, ERIKA VAL-ENTI, MEGAN WALDRAM, AND DAVID WEININGER. THEIR UNCOMPROMISING PROFESSIONALISM, DISCERNMENT, AND UNWAVERING FAITH TURNED AN IDEA INTO A BOOK.

THANK YOU TWO:

SUNČICA AND DEBORAH

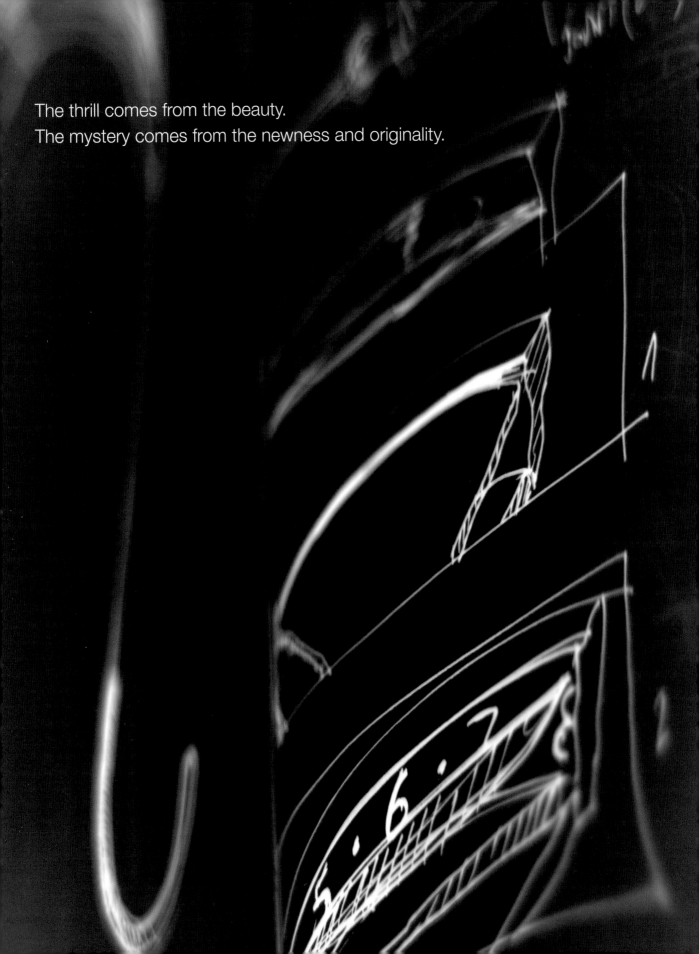

The thrill comes from the beauty.
The mystery comes from the newness and originality.

FOREWORD

I FELT BOTH A SENSE OF THRILL AND OF MYSTERY WHEN I FIRST ENCOUNTERED BRANKO LUKIĆ'S NONOBJECT PROJECT. I WAS BROWSING HIS WEBSITE FOR THE FIRST TIME WHEN I CLICKED ON THE FIRST PREVIEW TO ARRIVE AT *CUIN5*. THE VIDEO STARTED WITH THE GENTLE TINKLE OF ECHOING SYNTHESIZED NOTES, AS A SERIES OF QUESTIONS, ANSWERS, AND PROMISES WERE POSED IN CRYPTIC SENTENCES ON THE SCREEN. NEXT THE MUSIC TURNED MORE RHYTHMIC AND THE *SUPERPRACTICAL* MOBILE PHONE OF MANY FACES CAVORTED IN FRONT OF ME, TWISTING AND TURNING TO SHOW EACH FACE COVERED WITH ACTIVE BUTTONS AND LEGENDS, WITH THE BUTTONS DEPRESSING IN TIME TO THE MUSIC. WITH A WHOOSH IT SPUN AWAY TO ALIGHT ON A SURFACE AND HOVER ON EDGE, DANCED A FEW PIROUETTES, AND EMITTED A MOMENTARY GLOW OF THE GRAPHIC LEGENDS. THE RECTILINEAR FORM WAS ELEGANTLY SIMPLE, ALMOST MONOLITHIC, WITH SMOOTHLY SHINING SURFACES AND DELICATELY PRECISE GAPS BETWEEN THE BUTTONS. THE GRID OF BUTTONS WAS GENTLY ANGLED ON TWO OF THE SIDES. THE ILLUMINATED TYPOGRAPHY OF NUM-BERS AND LETTERS WAS SIMPLE AND BOLD, SET FLUSH WITH THE SURFACES OF THE KEYS. SUBTLE DETAILS EMBELLISHED THE SURFACE, WITH TACTILE BUMPS TO IDENTIFY THE NUMBER FIVE KEY, AND NOTCHED CORNERS TO REVEAL THE MICROPHONE LOCATION. THIS WAS A BEAUTIFUL DESIGN, BUT IT WAS NOT A NORMAL OBJECT!

THE THRILL CAME FROM THE BEAUTY. BENEATH THOSE SMOOTH SURFACES AND ELEGANT LINES WAS THE SURE HAND OF A GREAT DESIGNER, CONFIDENT IN THE DEFINITION OF PROPOR-TIONS, SURFACES, AND DETAILS. IT WAS NOT THE FORM ALONE, AS THE ANIMATION OF THE VIDEO DEMONSTRATED A MASTERFUL COMMAND OF REFLECTION, MOVEMENT, ILLUMINATION, AND TIM-ING, SHOWING THE ABILITY TO CREATE THRILLING DESIGNS THAT COMBINED PHYSICALITY WITH

MOVEMENT AND SOUND, EXISTING IN MULTIPLE DIMENSIONS AND MEDIA. THE MYSTERY CAME FROM THE NEWNESS AND ORIGINALITY. WHAT WAS THE THINKING BEHIND THIS EXPRESSION? WAS IT CONCEPTUAL ART OR PRACTICAL PROBLEM SOLVING? WHAT DOES *NONOBJECT* IMPLY, AND HOW CAN YOU DESIGN FROM THE SPACE BETWEEN YOU AND THE OBJECT? AT FIRST IT SOUNDS LIKE TYPOGRAPHY, WHERE EVERY GRAPHIC DESIGNER LEARNS TO LOOK AT THE SPACES BETWEEN THE CHARACTERS, AS WELL AS THE SHAPE OF THE ACTUAL LETTERS AND NUMBERS, BUT NO, THIS "SPACE BETWEEN" IS MORE SIGNIFICANT AND AT FIRST SIGHT MYSTERIOUS.

BARRY KĀTZ HELPS TO REVEAL THE MYSTERY. IN THE INTRODUCTION, HE EXPLAINS EVERYTHING IN HIS INIMITABLE PROSE, DRAWING ON HIS RICH KNOWLEDGE OF DESIGN AND HISTORY. HE NOTICES THREE METHODOLOGIES AT WORK—HUMOR, DISRUPTION, AND EXTRAPOLATION—ABOUT WHICH HE SAYS, "THIS THIRD DEVICE IS THE SUBTLEST BUT ALSO THE MOST CRITICAL TO UNDERSTANDING THE THOUGHT PROCESS UNDERLYING THE NONOBJECT; IT IS WHAT I WOULD CALL EXTRAPOLATION. THE BEST WAY TO EXPLORE THE VALIDITY OF AN IDEA IS TO TURN IT INTO A METAPHYSICAL ABSOLUTE AND EXTEND IT INFINITELY IN EVERY DIRECTION." READ ON AND YOU WILL FIND THE ANSWERS TO SEVERAL OF MY MYSTIFIED QUESTIONS, BOTH IN THE INTRODUCTION AND IN THE DESCRIPTIONS OF THE PROJECTS, ILLUMINATED BY ENGAGING ANALOGIES AT THE START OF EACH CHAPTER. KĀTZ EXPLAINS THE NONOBJECT POINT OF VIEW, SO I WANT TO RETURN TO MY SENSATION OF THRILL AND MYSTERY, TO COMPARE IT WITH MY RESPONSES TO OTHER DESIGN REVELATIONS.

THE FIRST TIME THAT I SAW THE WORK OF DIETER RAMS, EXEMPLIFIED BY HIS MINIMALIST PHILOSOPHY OF "WENIGER, ABER BESSER," (LOOSELY, "LESS, BUT BETTER"), I FELT A SENSE OF CALM ADMIRATION, REALIZING THAT EVERY ELEMENT OF THE FORMAL EXPRESSION HAD EXPLICIT RATIONALE AND THAT THERE WERE NO TREATMENTS ADDED WITH AN INTENTION TO ENHANCE EMOTIONAL RESPONSES OR EMBELLISH THE PURITY OF THE EXPERIENCE. THE WORK WAS GREAT, BUT THERE WAS NO FEELING OF THRILL OR MYSTERY.

I WAS THRILLED WHEN I FIRST ENCOUNTERED THE DESIGNS BY ETTORE SOTTSASS AND MARIO BELLINI FOR OLIVETTI AND PHILIPPE STARCK FOR ALESSI. THE THRILL CAME FROM THE

WONDERFUL USE OF FORM AND COLOR TO EXPRESS THE CONNECTIONS BETWEEN PEOPLE AND TECHNOLOGIES THAT WERE STARTLINGLY NEW AT THE TIME; THERE WAS SOME SURPRISE AT THE INGENUITY OF THE INNOVATIONS, BUT NO LASTING MYSTERY. INITIALLY I DID FEEL A LITTLE MYSTIFIED WHEN ETTORE CREATED THE MEMPHIS MOVEMENT, WITH ITS INCONGRUOUS FORMS AND REBELLIOUS DECORATIONS, BUT SOON CAME TO SEE IT AS A COLLECTION OF JOKES AT THE EXPENSE OF MODERNISM, GIVING DESIGNERS RENEWED FREEDOMS TO EXPLORE OUTSIDE THE REALM OF FUNCTIONAL PROBLEM SOLVING. PHILIPPE STARCK COMBINED THRILLING NATURAL FORMS WITH JOKES, REFLECTING A SENSE THAT ORGANIC DIVERSITY WAS MORE MEANINGFUL THAN MACHINED PERFECTION. AGAIN, I ENJOYED THE THRILL BUT FELT NO MYSTERY.

THE ONLY OTHER TIME THAT I HAVE FELT THRILLED AND MYSTIFIED IN A SIMILAR WAY TO THAT ENGENDERED BY BRANKO LUKIĆ CAME FROM WORKING WITH NAOTO FUKASAWA. NAOTO JOINED ME IN IDEO'S SAN FRANCISCO OFFICE, BEFORE RETURNING TO TOKYO TO LEAD OUR OFFICE THERE, SO I KNEW HIS WORK INTIMATELY. HIS THRILLING COMMAND OF AESTHETICS HAS SOMETHING IN COMMON WITH BRANKO'S, AS WELL AS THAT OF JASPER MORRISON AND JONATHAN IVE'S TEAM AT APPLE. NAOTO'S VISUAL SENSIBILITY AND SPIRITUALITY ARE INFORMED BY HIS EXPERTISE IN MODERN INTERNATIONAL DESIGN COMBINED WITH A DEEP AWARENESS OF TRADITIONAL JAPANESE BEAUTY. I WROTE AN ESSAY FOR HIS MONOGRAPH, *NAOTO FUKASAWA*, TO EXPLAIN THIS, RECOUNTING THE MAGICAL EXPERIENCE OF VISITING THE MEIJI SHRINE IN TOKYO WITH HIM AS A GUIDE. ALL OF NAOTO'S WORK THRILLS ME, OFTEN SENDING CHILLS DOWN MY SPINE FROM THE COMBINATION OF BEAUTY AND EMOTIONAL POWER, BUT IT IS NOT NORMALLY MYSTERIOUS. THE MYSTERY CAME WHEN HE WROTE AN EXPLANATION OF HIS PERSONAL AESTHETIC STANCE, SUMMED UP IN THE JAPANESE WORD *HARI*: "*HARI* ("IN-TENSION") IS THE ESSENCE OF DESIGN. *HARI* IS ORIGINALLY A PHYSICAL TERM EXPRESSING THE PRESSURES EXERTED UPON AN OBJECT, THE PROCESS OF THIS EXERTION, OR THE POWER INHERENT THEREIN. . . . IN JAPAN, *HARI* HAS LONG BEEN USED METAPHORICALLY TO EXPRESS SOMETHING ABOUT THE HUMAN SPIRIT."

I KNOW THAT THIS PHILOSOPHY IS INHERENT TO NAOTO'S EXCELLENCE, AND I KNOW THAT IT'S ORIGINAL AND IMPORTANT, BUT I STILL FIND IT MYSTERIOUS. I TEST MYSELF BY TRYING

TO IDENTIFY OBJECTS THAT HAVE *HARI* AND THEN CHECKING WITH NAOTO. I'M OFTEN WRONG, CAUSING HIM TO SHAKE HIS HEAD IN SAD BEWILDERMENT.

THE MYSTERY IN NONOBJECT HAS A LOT IN COMMON, FOR ME AT LEAST, WITH THAT POSED BY *HARI*. I KNOW THAT IT IS ORIGINAL, NEW, PROFOUND, AND IMPORTANT. I THINK IT WILL CHANGE THE WAY WE THINK ABOUT DESIGN AND DESIGNING. I LOVE THE HUMOR, THE DISRUPTION AND THE THOUGHT OF EXTENDING METAPHYSICAL ABSOLUTES INFINITELY IN EVERY DIRECTION. THE MYSTERY REMAINS WHETHER I CAN DO IT MYSELF, TO OPERATE SUCCESSFULLY IN WHAT BRANKO CALLS "THE SPACE BETWEEN." PERHAPS THAT UNCERTAINTY IS A GOOD THING, AS THE SENSE OF WONDER AND ADMIRATION FOR THE CONTRIBUTION THAT NONOBJECT MAKES TO DESIGN IS ENHANCED BY THE COMBINATION OF THRILL AND MYSTERY.

BILL MOGGRIDGE
DIRECTOR, COOPER-HEWITT NATIONAL DESIGN MUSEUM

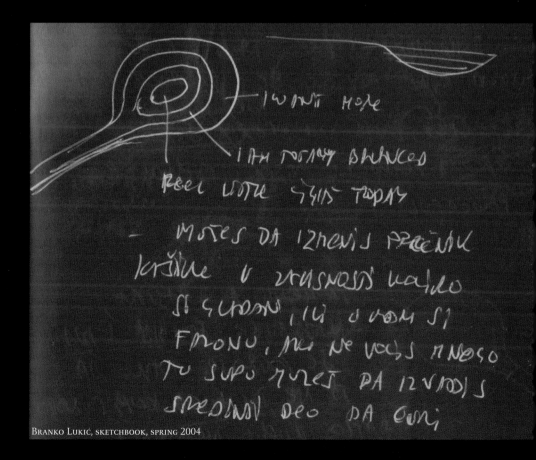

BRANKO LUKIĆ, SKETCHBOOK, SPRING 2004

Music lies in the space between the notes.
—Claude Debussy

INTRODUCTION

SOME NONOBJECT(IVE) REFLECTIONS

ON THE NONOBJECT

FOR A HUNDRED YEARS DESIGNERS HAVE BEEN BOTH INSPIRED AND IMPRISONED BY THE MYSTIQUE OF FUNCTIONALISM—THE IDEA, SIMPLY STATED, THAT THE LEGITIMACY OF AN OBJECT, WHETHER INDUSTRIAL, ARCHITECTURAL, OR TYPOGRAPHIC, DERIVES FROM ITS PERFORMANCE. WOMEN'S SHOES, AMERICAN CARS, AND A NOTABLY SMALL NUMBER OF OTHER CATEGORIES SEEM TO HAVE BEEN EXEMPTED FROM THIS STANDARD, BUT THEY MAY BE THE EXCEPTIONS THAT PROVE THE PROVERBIAL RULE: "FORM EVER FOLLOWS FUNCTION," DECREED LOUIS SULLIVAN A CENTURY AGO; "THIS IS THE LAW."

ONLY A FEW LONE VOICES DARED TO CHALLENGE REDUCTIVE DOGMA THAT FORM FOLLOWS FUNCTION. THE ENGLISH DESIGN CRITIC REYNER BANHAM DISMISSED IT AS "A MEANINGLESS JINGLE" THAT COULD NOT WITHSTAND SERIOUS SCRUTINY. THE ITALIAN ETTORE SOTTSASS, ONE OF THE SINGULAR VISIONARIES OF MODERN DESIGN, WAS MORTIFIED BY THE IDEA THAT MECHANICAL EFFICIENCY OR MANUFACTURING ECONOMY COULD SUBSTITUTE FOR "THE MORE PROFOUND FUNCTIONALISM" OF POLITICS, CULTURE, AND THE PSYCHE.

IT WAS THE ARRIVAL OF THE MICROCHIP, HOWEVER, THAT DEALT THE LETHAL BLOW TO THE FUNCTIONALIST DECREE THAT THE OUTER FORM OF AN OBJECT MUST EXPRESS ITS INNER WORKINGS. THE HOUSEHOLD APPLIANCES THAT ANNOUNCED THE BEGINNING OF THE MODERN AGE APPEARED ESSENTIALLY AS METALLIC SKINS WRAPPED MORE OR LESS TIGHTLY AROUND ELECTRIC MOTORS, HEATING COILS, VACUUM TUBES, ETC. BUT WHAT HAPPENS WHEN, UNDER THE REGIME OF THE

MICROPROCESSOR, THE POWER PLANT OF AN ELECTRONIC APPARATUS SHRINKS TO A SCALE THAT IS UNRELATED IN ANY MEANINGFUL WAY TO CLASSICAL ERGONOMICS? THE SHAPE OF A MODEM IS, IF NOT ARBITRARY, AT LEAST SUBJECT TO AN ENTIRELY DIFFERENT SET OF DETERMINANTS. ONCE AGAIN, THE DEBATE WAS THROWN OPEN: WHAT IS AN OBJECT? HOW SHOULD WE RELATE TO IT? HOW, TO PARAPHRASE DEBUSSY, CAN WE LEARN TO LISTEN TO THE MUSIC THAT LIES IN THE MYSTERIOUS SPACE BETWEEN OURSELVES AND THE OBJECTS WE USE?

ENTER BRANKO LUKIĆ.

BRANKO IS AN INDUSTRIAL DESIGNER WITH ROOTS IN SERBIA AND SILICONIA. HE RECEIVED HIS TRAINING IN INDUSTRIAL DESIGN AT THE ACADEMY OF APPLIED ARTS IN BELGRADE—NOT EXACTLY ONE OF THE WORLD'S LEADING DESIGN CENTERS IN THE EARLY NINETIES—WHERE HE AND HIS FRIENDS FOUGHT OVER THREE-YEAR-OLD COPIES OF *I.D. MAGAZINE*, WHEN THEY COULD FIND THEM. BUT HE LEARNED TO ADMIRE THE WORK OF THE JAPANESE MASTERS SHIRO KURAMATA AND TADAO ANDO, ALVAR AALTO OF FINLAND, AND JACOB JENSEN OF DENMARK. ALTHOUGH YUGOSLAVIA WAS ALWAYS THE MOST WESTERNIZED OF THE SOCIALIST NATIONS, IT HAD (FOR BETTER OR FOR WORSE) ALMOST NO TRADITION OF CONSUMER PRODUCT DESIGN, AND BRANKO'S WORK DURING THAT PERIOD CONSISTED MAINLY OF EXPERIMENTS, INVESTIGATIONS, AND PROTOTYPES. HE COMPLETED HIS STUDIES IN 1993, JUST AS YUGOSLAVIA WAS SLIDING INTO CHAOS AND THE SERBIAN ECONOMY WAS TEETERING ON THE VERGE OF COLLAPSE.

FRESH OUT OF SCHOOL, BRANKO AND A FEW FRIENDS STARTED AN ADVERTISING AGENCY THAT MANAGED TO CARVE OUT A NICHE FOR ITSELF IN THE EARLY YEARS OF ECONOMIC PRIVATIZATION, BUT ALL THE WHILE HE CONTINUED HIS PARALLEL EXPERIMENTS IN ART AND DESIGN. THE OPPORTUNITY TO MOVE FROM *SPECULATING* ABOUT THE FUTURE TO *DESIGNING* IT CAME WHEN HE MET HARTMUT ESSLINGER, FOUNDER OF THE FROGDESIGN STUDIO, THE FIRST TO IMPORT A REFINED EUROPEAN DESIGN AESTHETIC TO THE UNTAMED AMERICAN WEST. IN 1998 LUKIĆ JOINED FROGDESIGN'S BURGEONING OFFICE IN SUNNYVALE, IN THE HEART OF SILICON VALLEY, WHERE HE WORKED ON TECHNOLOGY PROJECTS FOR AT&T, MICROSOFT, AND MOTOROLA, BUT ALSO MORE TRADITIONAL PRODUCTS FOR COMPANIES SUCH AS CRAFTSMAN AND FORD. AFTER A FEW YEARS

He was recruited by the design firm IDEO and moved up the road to Palo Alto, where he immersed himself in IDEO's culture of human-centered design and started to focus on consumer experience. He quickly rose to the position of lead designer, and his work during those years garnered national and international awards and brought significant business success to his clients.

Everyone who has ever met Branko or listened to him speak has been struck by his peculiar combination of passion and humility. "Growing up in Serbia," he says, "I did not know that there was a 'job' that was to make things better." When he found it—industrial design—he also found himself, and he has not wavered. In 2006 he finally yielded to his inner drive. With his wife, Sunčica, a business partner, Steve Takayama, and a determination that can at times be nothing short of terrifying, he founded Nonobject. Working with a global client base that includes companies large and small, Nonobject brings an otherworldly vision to the sober realities of business. In doing so, it seeks to redefine the possibilities of professional practice today.

The walls of Nonobject are covered with sketches of work in progress and photographs of past projects: a telephone system for Cisco, office furniture for Steelcase, a gracefully elongated bicycle saddle for fi'zi:k. These might be called the "facts" of life in a small multidisciplinary design studio. But then there are the images of the imaginary Tarati cell phone and the nonexistent Inner line of wristwatches that seem to belong to another planet. These are his "design fictions" and the subject of this book. There is no easy dividing line, however, between the prosaic world of clients and budgets and deadlines and the poetic reveries resolved to such an astonishing level of detail. Fact and fiction interpenetrate and inform and discipline one another in the nonobjective universe. Branko's clients gain a poetic treatment of the everyday; his readers gain a prosaic grounding for the most speculative explorations.

He can achieve this remarkable blend of dream and reality because he has paid his professional dues. His tenure at the two preeminent Silicon Valley consultancies left

HIM WITH AN INTIMATE KNOWLEDGE OF EVERYTHING FROM FUNCTIONAL AFFORDANCES TO VIABLE BUSINESS PLANS. WHEN HE INTRODUCES THINIUM—AN ELEMENT THAT EXISTS ON NO PERIODIC TABLE—IT'S BECAUSE HE HAS WORKED WITH CAST ALUMINUM, HIGH-DENSITY POLYMERS, AND STATE-OF-THE-ART PROTOTYPING EQUIPMENT AND KNOWS PERFECTLY WELL WHAT THEY CAN AND, MORE IMPORTANTLY, CANNOT DO. WHEN HE POSTULATES A BICYCLE THAT CANNOT (YET) BE RIDDEN OR A CHAIR THAT CANNOT BE MANUFACTURED, SHIPPED, OR SAT UPON, IT IS NOT BECAUSE HE IS IGNORANT OF ERGONOMICS BUT BECAUSE HE UNDERSTANDS THAT THE MEASUREMENT OF THE HUMAN BODY IS NO SUBSTITUTE FOR THE INVESTIGATION OF THE HUMAN CONDITION.

ARCHITECTS HAVE A LONG TRADITION OF WHAT IN ITALY IS CALLED *ARCHITECTURA DA CARTA*, VISIONARY EXPLORATIONS OF THE UNBUILT AND THE UNBUILDABLE. FROM THE FUTURIST ANTONIO SANT'ELIA TO THE URBANIST DANIEL LIEBESKIND, THEY HAVE OFTEN PREFERRED THE MEDIUM OF PENCIL AND PAPER TO BRICKS AND MORTAR, GLASS AND STEEL: TO HELL WITH HVAC, BUILDING CODES, AND EVEN GRAVITY! IF WE ARE TO PURIFY OUR THINKING WE MUST BEGIN BY REFUSING EVERY COMPROMISE AND REJECTING EVERY CONSTRAINT. INDUSTRIAL DESIGNERS, BY CONTRAST, HAVE RARELY VENTURED MUCH BEYOND THE OCCASIONAL CONCEPT CAR OR LUXURY CONCEIT. ONCE OUT OF SCHOOL THEIR BRAVADO WILTS IN THE FACE OF CLIENTS, SCHEDULES, AND BUDGETS, AND FEW HAVE DARED TO USE DESIGN AS AN EPISTEMOLOGICAL PROBE, A MEANS OF SURVEYING THE BOUNDS OF THE BELIEVABLE AND PRESSING AGAINST THE PERIMETER OF THE POSSIBLE. BRANKO IS A SINGULAR EXCEPTION.

I HAVE HAD THE OPPORTUNITY TO MONITOR SOME PRELIMINARY RESPONSES TO BRANKO'S FORAYS INTO THE MYSTERIOUS WORLD OF THE NONOBJECT, AND THEY ARE JUST AS THEY SHOULD BE. ON THE RIGHT (AS IT WERE), SKEPTICS HAVE RESPONDED WITH THE PREDICTABLE, "THAT WILL NEVER WORK" OR, "NOBODY WOULD EVER BUY IT" OR, "IT WOULD BE IMPOSSIBLE TO PRODUCE." THESE ARE DESCENDENTS OF THE SAME BENIGHTED SOULS WHO COMPLAINED THAT PICASSO PAINTED TWO EYES ON THE SAME SIDE OF A WOMAN'S HEAD, AND THERE'S NOT MUCH THAT CAN BE OFFERED TO THEM BUT OUR CONDOLENCES. ON THE LEFT THERE ARE THE SANCTIMONIOUS ACCUSATIONS THAT IT IS IRRESPONSIBLE TO INDULGE IN "DESIGN FICTIONS" WHEN GLACIERS ARE MELTING, RE-

SOURCES ARE DWINDLING, AND WMDS ARE PROLIFERATING. TO THEM WE MUST RESPECTFULLY DEMUR. WHAT BETTER TIME TO SEARCH FOR QUALITATIVE ALTERNATIVES TO THE PREVAILING ORDER OF THINGS? A PRIUS IS CERTAINLY CLEANER THAN A HUMMER, BUT BRANKO'S ASTONISHING nUCLEUS ZERO-EMISSION MOTORCYCLE—WHICH CAN (FOR THE TIME BEING) BE RIDDEN ONLY ACROSS THE TERRAIN OF THE IMAGINATION—IS CLEANEST OF THEM ALL.

ALTHOUGH OFTEN REDUCED TO UTILITARIAN PROBLEM SOLVING, THERE IS AN ASPECT OF DESIGN THAT MIGHT BETTER BE DESCRIBED AS "CULTURAL RESEARCH." BEFORE A PROBLEM CAN BE SOLVED IT MUST BE ANALYZED, EXPLORED, AND DEFINED IN ALL OF ITS DIMENSIONS, AND BRANKO'S CONVICTION THAT DESIGN BEGINS IN THE SPACE BETWEEN THE USER AND THE OBJECT IS THE STARTING POINT FOR THIS TASK. AS I REVIEW HIS REMARKABLE BODY OF WORK, I FIND THREE METHODOLOGIES AT WORK.

FIRST, THERE IS THE LETHAL INSTRUMENT OF HUMOR, WHICH, AS FREUD REMINDED US SO POINTEDLY, IS NO LAUGHING MATTER. BRANKO'S iEAT DIET SPOON (AND WHAT DESIGNER OF ANY STATURE—FROM HENRY VAN DE VELDE AND PETER BEHRENS TO RENZO PIANO AND MICHAEL GRAVES—HAS NOT PAUSED TO WORK ON THE PROBLEM OF THE SPOON?) BRINGS A SMILE TO THE LIPS BUT, BECAUSE OF ITS CLEVER WEIGHT-ACTIVATED HINGE, NOT MUCH ELSE. THE RAWPHISTICATED CELL PHONE IS SURELY MORE INTERESTING THAN ANYTHING I COULD POSSIBLY SAY INTO IT. NOTHING IS MORE LIBERATING THAN LAUGHTER, SO LONG AS IT'S UNDERSTOOD THAT IT MARKS THE BEGINNING OF THE PROCESS OF SELF-ANALYSIS, AND NOT—LIKE THE INEVITABLE PUNCH LINE OF A PREDICTABLE JOKE—THE END.

SECOND, BRANKO ENGAGES IN THE TACTIC OF DISRUPTION. SOMETIMES THIS TAKES THE FORM OF SLIGHTLY ALTERING A FAMILIAR ARTIFACT IN ORDER TO CAST IT IN A DIFFERENT, SHARPER LIGHT—THE UPSIDE-DOWN KISHA UNBRELLA. SOMETIMES IT INVOLVES COMBINING TWO HITHERTO UNRELATED PHENOMENA: THE INNER DRIVE OF ANGER (AT THE STATUS QUO?) PLUS THE ORDINARY LIGHT SWITCH EQUALS THE enLIGHTEN SWITCH THAT IS OPERATED BY A CLENCHED FIST. THE FINGERTIP, ACCORDING TO THE LATE MEDIA THEORIST VILÉM FLUSSER, IS FAST BECOMING

THE DEFINING ORGAN OF THE DIGITAL (DIGIT-ALL) AGE, AND BRANKO PERFORMS A DARING RESCUE OPERATION TO REHABILITATE THE HUMAN BODY.

HIS THIRD DEVICE IS THE SUBTLEST BUT ALSO THE MOST CRITICAL TO UNDERSTANDING THE THOUGHT PROCESS UNDERLYING THE NONOBJECT; IT IS WHAT I WOULD CALL EXTRAPOLATION. THE BEST WAY TO EXPLORE THE VALIDITY OF AN IDEA IS TO TURN IT INTO A METAPHYSICAL ABSOLUTE AND EXTEND IT INFINITELY IN EVERY DIRECTION. THIS IS THE PRINCIPLE THAT GOVERNS THE FAMILY OF RIGHT-ANGLED NONOBJECTS CALLED 90 DEGREES: THE CUTLERY SET WITH ITS "BARBARIAN ELEGANCE," THE STAPLER THAT PAYS HOMAGE TO THE 90-DEGREE ARCHITECTURE OF THE PAGE, THE FRIGHTENING RIGHT BIKE, WHOSE UNCOMPROMISING RECTILINEARITY IS EXPRESSED IN EVERYTHING BUT THE WHEELS (WHY NOT THE WHEELS AS WELL, BRANKO?). IT IS AT WORK IN THE COLLECTION OF NONOBJECT CALLED THE IMPOSSIBLES, WHICH EXPLORE THE CHANGES IN PERCEPTION THAT OCCUR WHEN WE ALTER THE KNOWN AND FAMILIAR. RADICAL EXTRAPOLATION HELPS US TO SEE WHAT AN IDEA *IS*; THERE WILL BE TIME, LATER ON, TO DECIDE WHETHER OR NOT IT IS ANY GOOD.*

WHOEVER PUZZLES OVER BRANKO'S VARIOUS LINES OF NONOBJECTS—THE SUPERPRACTICAL, THE POSTINTUITIVE, THE HYPERSENSORY, THE RAWPHISTICATED—WILL COME UP WITH BETTER CATEGORIES THAN THESE, AND THAT'S PROBABLY THE POINT. AGAIN, CLIENTS LOOK AT A DESIGN AND ASK THE DESIGNER TO EXPLAIN IT; READERS UNDERSTAND THAT THE POINT OF AN IDEA IS TO STIMULATE THOUGHT, AND THIS IS WHAT NONOBJECT SEEKS TO DO. IF WE ARE TO EXPLORE THE SPACE BETWEEN THE SELF AND THE OBJECT, WE MUST FIRST LOOSEN THE BONDS OF THE FUNCTIONAL AND SET OUR IMAGINATIONS ADRIFT.

IT IS ESSENTIAL TO UNDERSTAND WHAT IS AT STAKE IN THESE EXERCISES, LEST THEY BE MISTAKEN FOR FLIGHTS OF ARTISTIC FANTASY, OF TECHNICAL VIRTUOSITY, OR THE EXERTIONS OF A RICH BUT OVERHEATED IMAGINATION. TO BE SURE, WE ARE BEING ASKED TO THINK BEYOND THE CONSTRAINTS AND CONVENTIONS OF DESIGN PRACTICE AND THE STUFF THAT IS TROTTED OUT EVERY YEAR AT CES (CONSUMER ELECTRONICS), NEOCON (CONTRACT FURNITURE), AND ALL THE OTHER

INDUSTRY TRADE SHOWS. MORE FUNDAMENTALLY, HOWEVER, NONOBJECT DEMANDS NOTHING LESS THAN THAT WE RETHINK THE SPACE OPENED UP BY OUR KINSMAN, *HOMO HABILIS*, THE ORIGINAL TOOLMAKER, AND THE TOOLS WE HAVE COME TO DEPEND UPON TO NAVIGATE OUR COMPLEX WORLD. THE DESIGN EXPERIMENTS PRESENTED HERE ARE APPLIED ANTHROPOLOGY, PSYCHOLOGY, AND SOCIOLOGY. IN THEIR BALANCE BETWEEN PRECISE TECHNICAL EXECUTION AND A POSTINTUITIVE, POSTERGONOMIC FUNCTIONALITY, THEY ARE AKIN TO THE MAGIC REALISM OF BORGES OR GARCÍA MÁRQUEZ AND REMINISCENT OF THE EERILY CONVINCING WORLD OF DALÍ OR MAGRITTE. THEY BEGIN WITH WHAT IS MOST FUNDAMENTAL TO THE HUMAN EXPERIENCE—OUR ABILITY TO CRAFT THE ARTIFACTS THAT DEFINE OUR PLACE IN THE WORLD—AND ASK HOW WE HAVE REDUCED THEM TO DULL COMMODITIES, MUTE PROPS RELEGATED TO THE BACKGROUND OF THE *THEATRUM MUNDI* OF OUR LIVES. NOT SINCE THE RUSSIAN CONSTRUCTIVISTS WAXED RHAPSODIC ABOUT "THE SOCIALIST OBJECT AS COMRADE" HAVE WE SEEN SUCH A SWEEPING VISION OF THE ROLE THAT OBJECTS MIGHT PLAY IN OUR LIVES.

IN THE FIRST, EUPHORIC YEARS OF THE BOLSHEVIK REVOLUTION, THE CONSTRUCTIVISTS—ALEKSANDR RODCHENKO AND VARVARA STEPANOVA, EL LISSITZKY AND VLADIMIR TATLIN—DARED TO IMAGINE THE COOKING STOVE OR THE STREETCAR OR THE OVERCOAT NOT AS HIRED HANDS APPOINTED TO CARRY OUT DESIGNATED TASKS BUT AS PARTNERS WHO SHARE WITH US A COMMON PURPOSE AND REVEAL TO US OUR COMMON DESTINY. THOSE DAYS ARE IRRETRIEVABLY GONE, BUT THE DREAM IS, IF ANYTHING, CLOSER TO REALITY THAN EVER. IT WAS SAID THAT THERE WAS NOT ENOUGH STEEL IN THE WHOLE OF THE SOVIET UNION IN 1919 TO BUILD TATLIN'S FANTASTIC MONUMENT TO THE THIRD INTERNATIONAL, BUT TODAY WE ARE LITERALLY AWASH IN SMART MATERIALS, FLEXIBLE MANUFACTURING, INTERACTIVE MEDIA, GENETIC ALGORITHMS, AND COMPUTATIONAL CLOUDS. UTOPIA, WHETHER AS POLITICAL AGENDA OR LITERARY TROPE, IS FINISHED. REALITY HAS GAINED THE UPPER HAND AND LEFT THE IMAGINATION IN THE DUST. THERE IS NOTHING WE CAN DREAM OF THAT WE CANNOT ACTUALLY DO.

THE PHILOSOPHY OF THE NONOBJECT RISES TO THIS HISTORIC CHALLENGE. IT USES DESIGN TO PROBE THE EMOTIONAL SPACE BETWEEN THE HUMAN AND THE ARTIFACTUAL AND SUBJECT IT TO PROFOUND EXAMINATION. IN SOME CASES THIS INVOLVES STATE-OF-THE-ART DIGITAL TECHNOLO-

GIES OR EXOTIC COMPOSITES; AT OTHER TIMES IT ASKS ONLY THAT WE LOOK FROM A DIFFERENT ANGLE AT OUR SHOES, OUR UMBRELLAS, OR THE FRONT DOORS OF OUR HOUSES. WE BARELY KNOW WHAT THEY ARE. WE RARELY STOP TO THINK ABOUT WHAT THEY MIGHT BE, AND WHO THEY MIGHT HELP US TO BE. BY UNDERSTANDING THE INFINITE POSSIBILITIES THAT INHERE IN OUR OBJECT WORLD WE CAN BETTER UNDERSTAND OURSELVES: HUMAN BEINGS, RECENT INDICATIONS NOTWITHSTANDING, ARE SOMETHING OTHER THAN VECTORS FOR DELIVERING BRANDS TO LANDFILLS.

THE IMPOSSIBLE DRIVES THE POSSIBLE. AT THE HEART OF THE NONOBJECT IS BRANKO'S CONVICTION THAT DESIGN HAS THE POWER TO REAWAKEN A SIXTH SENSE—THE SENSE OF WONDER. SINCE PLATO IT HAS BEEN UNDERSTOOD THAT THIS ALONE IS THE WELLSPRING OF PHILOSOPHY, AND NONOBJECT MAY BE THE FIRST APPROACH TO DESIGN THAT RISES TO THE LEVEL OF PHILOSOPHY.

BARRY M. KATZ

* THERE IS A FAMOUS PRECEDENT FOR THE METHODOLOGY OF RADICAL EXTRAPOLATION: IN 1905 THE NOVICE DESIGNER LUCIAN BERNHARD ENTERED A COMPETITION SPONSORED BY THE PRIESTER MATCH COMPANY. FIRST HE ELIMINATED THE TWO SMOKERS SITTING AT A CAFÉ TABLE WITH A BOX OF MATCHES BETWEEN THEM; THEN HE ELIMINATED THE TABLE; THEN THE MATCHBOX. WHAT REMAINED WERE TWO WOODEN MATCHES UNDER THE LETTERS, "PRIESTER." THE REJECTED SUBMISSION—RETRIEVED FROM A WASTEBASKET BY A FAR-SIGHTED CLIENT—CHANGED THE FACE OF GRAPHIC DESIGN.

$ 4.99

$ 2.99

$ 11.99

$ 8.99

Nonobject is an approach to design that begins
neither with the product nor with the person using it
but in the charged space in between.

NEW DIMENSIONS

One hundred years ago, the French newspaper *Figaro* published a violent rant from an unknown Italian poet: "We stand on the last promontory of the centuries!" declaimed Filippo Tomasso Marinetti; "Why should we look back, when what we want is to break down the mysterious doors of the Impossible? Time and Space died yesterday. We already live in the absolute."

With these verbal pyrotechnics, full of sound and fury, the Futurist movement was born, straining against the narrow dimensionality of old Europe. Time and space had been restructured by the motorcar, the airplane, and the subway. Night and day had been undone by the incandescent light bulb. Inner and outer had been thrown into confusion by x-rays and air conditioning. The human sensorium, it seemed, had been extended by the phonograph, the movie camera, and the radio. Marinetti demanded that his contemporaries slough off the old and march boldly into a new dimension.

The Futurists, with their adolescent infatuation with machines, their misogyny and militarism, and their unseemly flirtation with fascism, may have had the first word, but certainly they did not have the last. Today we have come to suspect that the dimensions of the electrical age, weighted down by its turbines and generators, are inadequate to our brave new world of servers and routers, and we are once again struggling to find the human face of the new dimension. Is it the virtual world of social networking? Of Web 3.0? Of the Cloud? Is it possible to think of interactivity itself as the wormhole into a new dimension?

Our goal, here, is to demonstrate the power of the Nonobject to open up new dimensions of experience. Nonobject is an approach to design that takes advantage of technical innovation but is not driven by it. It is human centered but does not pander to the market. It starts not with the user or the object but with the space between.

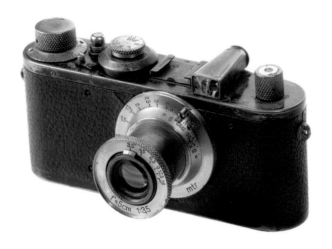

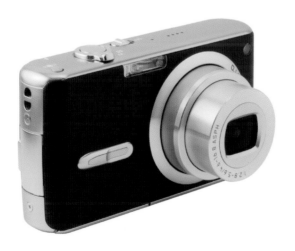

Behind-the-Scenes Camera

The measure of a camera's sophistication, sadly, is the proliferation of features and the number of megapixels someone has been able to cram onto a chip. Are we not ready for something more venturesome? Aren't we ripe for a concept that returns us to the magic of capturing a moment and freezing time?

The camera, in its spectacular 150-year history, has gotten better and better at capturing images of what we see before our eyes. Let's use it to expand our perceptual range so that it reveals what's going on behind us as well! Like other Nonobjects, the Behind-the-Scenes Camera is designed to reveal a more holistic and nuanced perspective. It offers a whole new way of experiencing time and space, and a whole new way of experiencing photography.

With today's cameras we are able to capture only one half of our travels, celebrations, and discoveries. What if we were able to expand the horizon of possibilities with a camera that captures the other half? The person taking the photo is able now to photograph Mt. Rainier through a rain-spotted windshield but also the restless kids misbehaving in the back seat. Behind-the-Scenes Camera gives us the scene in front of us and also takes us behind the scenes to a legitimate piece of the experience that we might not have seen and would otherwise never remember. The value of such a camera is more than a megapixel and more than a brand.

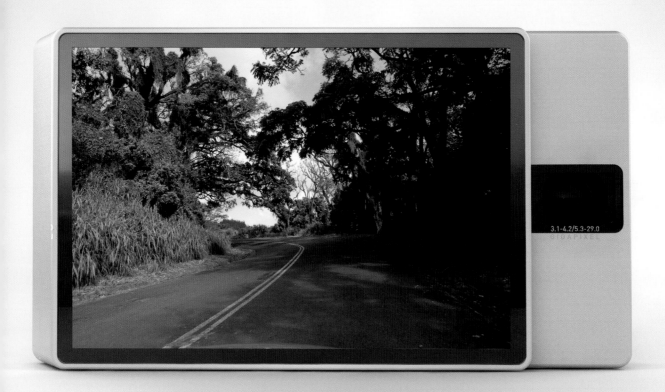

Front of camera

The scene

What you see

What you control

What you know

What you remember

What you can expect

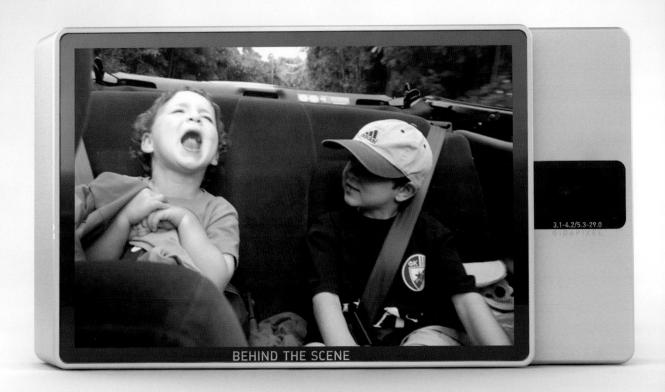

Back of camera

Behind the scene

What you don't see

What you don't control

What you don't know

What you don't remember

What you can't expect

The role of aesthetics is not to make things beautiful.
It is to awaken the senses.

HYPERSENSORY

If there is a job to put people to sleep—we call it anaesthesiology—why isn't there a job that pays to wake people up? Not to anaesthetize the senses but to invigorate them. To awaken them. To enliven them. Many people respond to the hyperstimulation of everyday life by narcotizing themselves with drugs or television so that they can drift off into the dreamless sleep of unfeeling. We believe the solution is not to dull our senses with *an*-aesthetics but to heighten them with aesthetics. Not less stimulation, but more.

Hypersensual Nonobjects seek to drive the aesthetic experience forward, not backward. Their aim is not to subdue our sense perceptions but to amplify and accelerate them. Not for the sake of more noise (we've got enough of that already!), but to make us more alert to the objects that surround us and more alive to the mysteries they conceal.

Take the spoon. Our kitchen drawers harbor dozens of mismatched spoons, but we do not give them the time of day. Thus do things become invisible to us, and thus do we become invisible to ourselves because we are numbed to the possibilities that inhere in our dazzlingly complex, mesmerizingly intricate object world. There are exceptions. Indeed, scarcely an architect or designer of note has not paused to ponder the problem of the spoon, but most of them have remained stuck within a pretty standard typology: a bucket or a shovel, embellished with appropriate period styling.

Our approach is different. We recall Scheherazade, weaver of 1001 tales across 1001 Arabian nights. Imagine, under a starry Arabian sky, 1001 microspoons, each targeting its own private taste bud, whispering to it, caressing it, seducing it, ravishing it with flavonoids and impregnating it with antioxidants. Never again will we be content to scoop up a mouthful of cereal while we attend to the morning newspaper—not when we have been awakened to the world of the hypersensory.

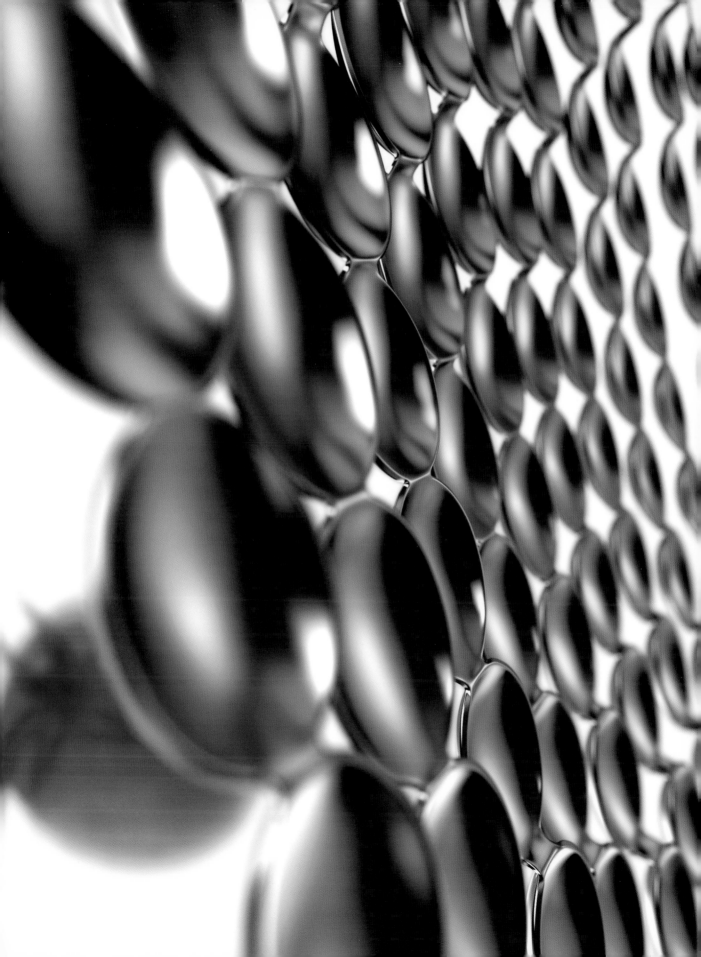

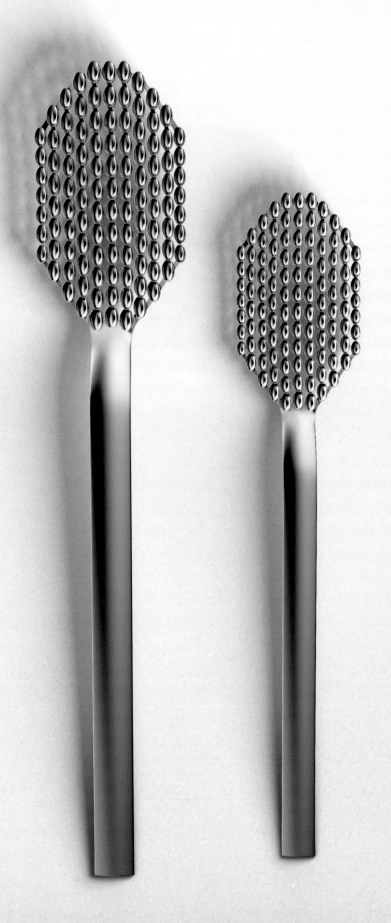

1001 Drops

Wine lovers know that it is important to select the stemware that best complements their chosen varietal, but soup lovers remain mired in the culinary dark ages. What if a spoon could advance beyond its simple functionality and actually heighten our experience of taste? What if it could cause each drop of flavor to burst over our taste buds like the popping of a thousand pomegranate seeds? That is the idea behind 1001 Drops, a single spoon made of myriad interconnected microspoons that brings the user into a more intimate connection with the sensation of taste. The 1001 Drops invites us to experience a different story—1001 stories. It begs us to imagine new and exotic ways of performing day-to-day activities.

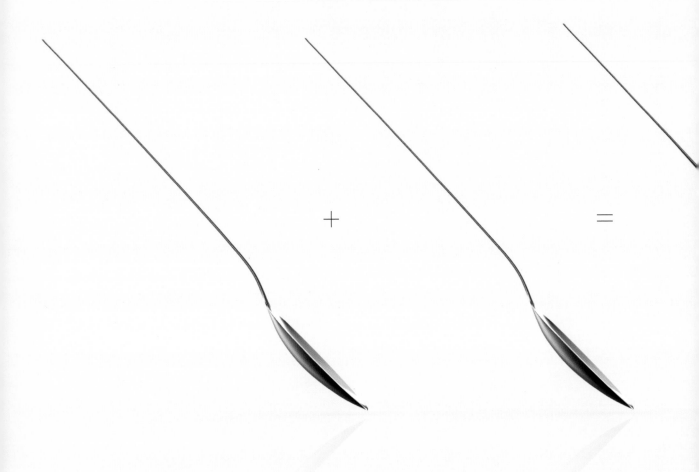

+ =

What are we *really* hungry for?

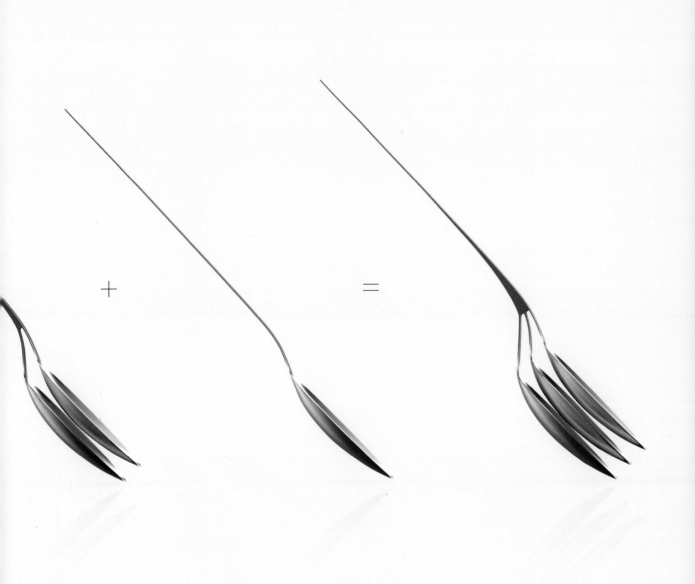

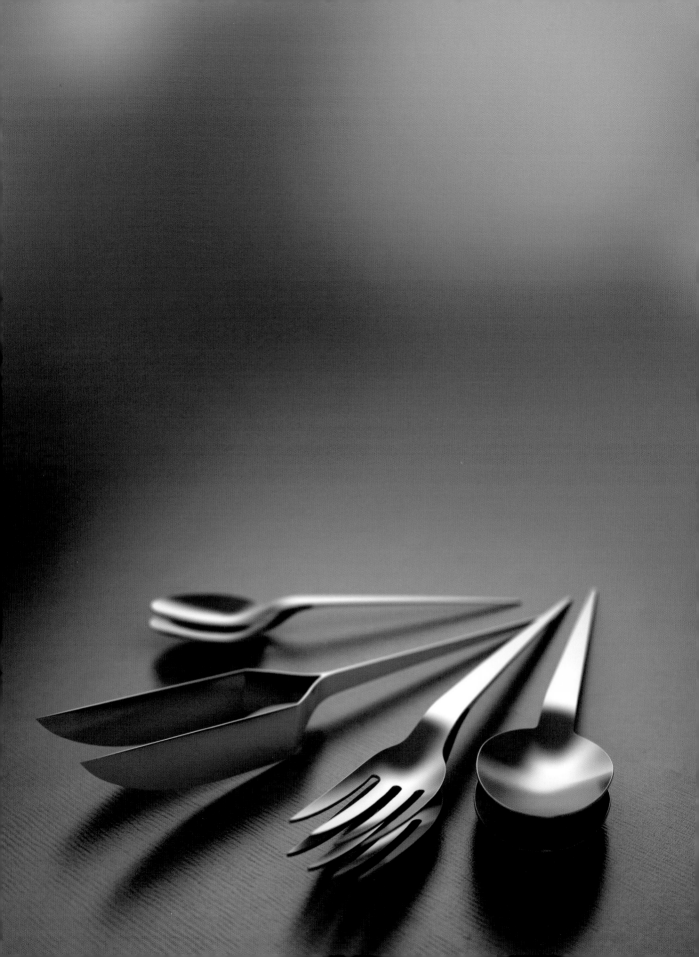

Hungry Set

For a sweet-and-sour commentary on our supersized food culture, we offer the Hungry Set. These doubled-up knives and spoons and forks allow us to increase by a factor of two the amount of food ingested per unit of time. The bold design of the Hungry Set challenges us to think about the ways in which our utensils may be complicit in the excesses of our culture. This cutlery set holds a mirror to a culture knitted together by filaments of speed, need, and greed. It forces us to question our relationship to food, and even to ask ourselves, "What are we *really* hungry for?"

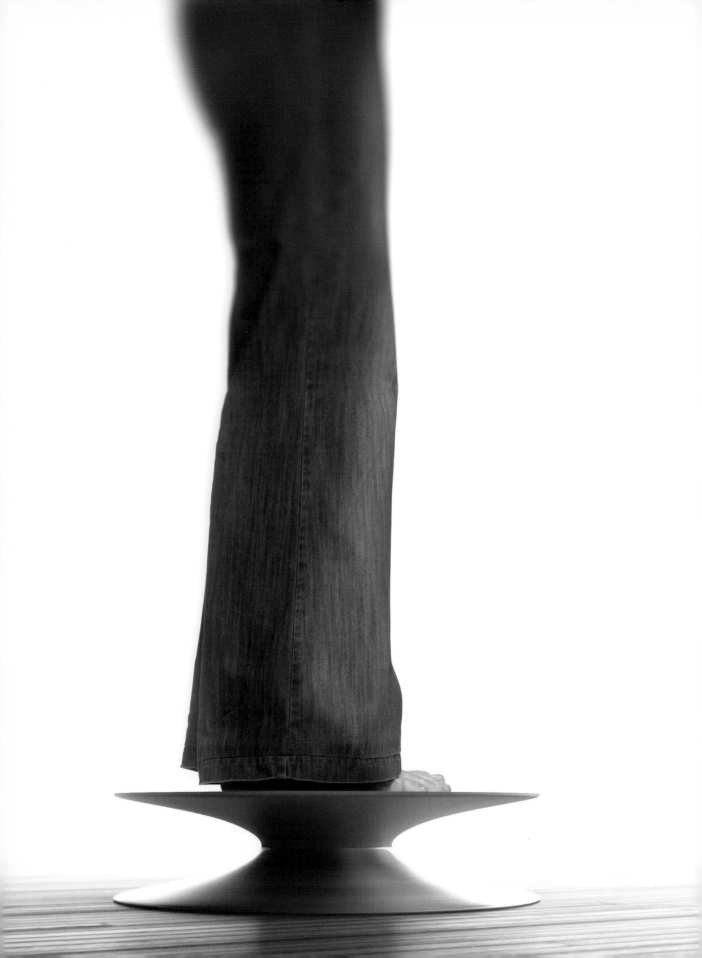

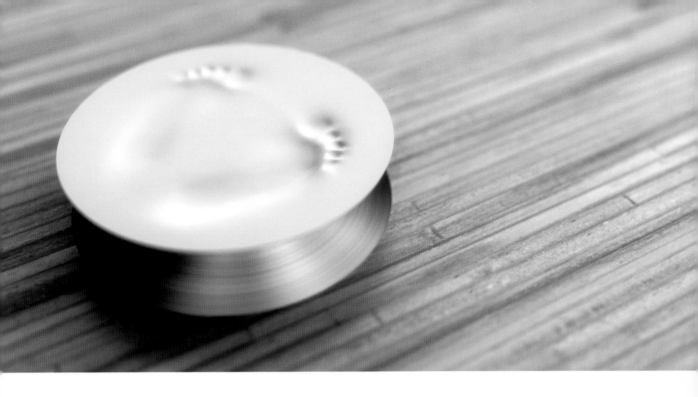

Threshold

Arriving home after a long day at work, it's important to mark the transition by crossing a threshold in a way that is both literal and figurative. It should be an act of purification that rinses away the worries of the day and allows us to give ourselves over fully to what's next—preparing a simple or an elegant meal, playing with the kids, relaxing in front of a rented movie. Threshold is intended for this purpose. It is a personal meditation point, literally, a "foot stool," imprinted with one's own soles. Home is where the heart is; home is where the sole is.

The impossible drives the possible.

IMPOSSIBLES

22.2
Thi
Thinium

WHEN IT COMES TO THE BASIC BUILDING BLOCKS OF MATTER, THE INTERNATIONAL UNION OF PURE AND APPLIED CHEMISTRY (IUPAC) HAS THE FINAL SAY: TO IT ALONE IS GRANTED WHAT NIETZSCHE CALLED "THE LORDLY RIGHT OF GIVING NAMES." THUS ELEMENT 101, RADIOACTIVE MENDELEVIUM, PAYS TRIBUTE TO DMITRI MENDELEEV, WHO PUBLISHED THE PERIODIC TABLE IN 1869. PB, FROM THE LATIN *PLUMBUM*, RECALLS THE ROMAN PLUMBERS WHO UNWISELY LINED THEIR AQUEDUCTS WITH LEAD. BUT LATELY THE NOMENCLATORS AT IUPAC HAVE BEEN STUMPED AND HAVE HAD TO MAKE DO WITH PLACEHOLDERS FOR THE FLEETING UNUNPENTIUM, WHICH DE-CAYED AFTER ONLY 100 MILLISECONDS; FOR THE ELUSIVE UNUNHEXIUM, OF WHICH ONLY EIGHT ATOMS HAVE BEEN DETECTED; FOR MYSTERIOUS UNUNSEPTIUM, WHOSE VERY EXISTENCE REMAINS A MATTER OF CONJECTURE AND DEBATE.

MENDELEEV PREDICTED, BASED ON THEIR PERIODICITY, THAT MORE ELEMENTS WOULD BE DISCOV-ERED, AND CHEMISTS AT THE PARTICLE ACCELERATORS OF BERKELEY AND DUBNA AND CERN, IN THE SPIRIT OF STRICT SCIENTIFIC OBJECTIVITY, HAVE PROVEN HIM RIGHT. BUT WHAT IF A WHOLE NEW *FAMILY* OF ELEMENTS WERE TO TAKE ITS PLACE ALONGSIDE THE LANTHANIDES AND THE ACTINIDES, THE HALOGENS AND THE NOBLE GASES? NONOBJECTIVE CHEMISTRY CALLS THEM THE IMPOSSIBLES. THESE ARE MATERIALS SO STRONG AND SO PURE AND SO LIGHT THAT WE CAN LIT-ERALLY BEND THEM TO OUR WILL. THINIUM WAS THE FIRST, AND NOW THERE IS HARDFLEX— IMAGINE A BICYCLE HELMET MANUFACTURED OUT OF A SINGLE PIECE OF MATERIAL THAT IS SOFT AND YIELDING ON THE INSIDE AND HARD ON THE EXTERIOR. OTHER IMPOSSIBLES WILL SURELY FOLLOW: TWISTIUM. EXTRUDIUM. PLEASURIUM. EACH IS CHARACTERIZED BY A SINGLE DEFINING PROPERTY THAT CAN BE EXTRAPOLATED TO THE FURTHEST REACHES OF THE IMAGINATION.

SOMETHING LIKE THIS HAPPENED ONCE BEFORE. IN 1940, THE EDITORS OF *FORTUNE* MAGAZINE BREATHLESSLY ANNOUNCED THE DISCOVERY OF "SYNTHETICA: A NEW CONTINENT OF PLASTICS." NITROCELLULOSE. ACRYLIC STYRENE. CAST PHENOLIC. NEOPRENE. THE FLEDGLING INDUSTRIAL DESIGN PROFESSION WAS RECRUITED EN MASSE TO SHOW WHAT COULD BE DONE WITH "THE MATE-

RIAL OF A THOUSAND USES." FIRE A BULLET INTO IMPREGNABLE BAKELITE, OR BUILD A ROCKET SHIP OUT OF LIGHTWEIGHT MELAMINE AND LAUNCH IT INTO OUTER SPACE.

THE NEW IMPOSSIBLES, HOWEVER, ARE DIFFERENT. UNLIKE THE INDUSTRIAL PETROCHEMICALS OF YESTERDAY, EVERY ONE OF THEM OCCURS NATURALLY, EVEN LUXURIANTLY, IN THE IMAGINATION. THEY REQUIRE NO MINES OR REFINERIES. THEY ARE FLEXIBLE, 100 PERCENT BIODEGRADABLE, AND LEAVE NO TOXIC RESIDUE OR BITTER AFTERTASTE. ONCE AGAIN, AS IN THE BRAVE NEW ERA OF PLASTICS, THE DESIGNERLY IMAGINATION IS BEING CHALLENGED TO EXPLORE THE BOUNDARIES OF THE GIVEN.

"IMPOSSIBLE? NE ME DITES JAMAIS CE BÊTE DE MOT!" THUS DECLARED MIRABEAU, POCKMARKED PATRIOT AND REVOLUTIONARY CHAMPION OF THE THIRD ESTATE: "IMPOSSIBLE? NEVER SPEAK THIS BEASTLY WORD TO ME!" THE ROLE OF THE IMPOSSIBLES IS TO SHOW US WHAT IS POSSIBLE.

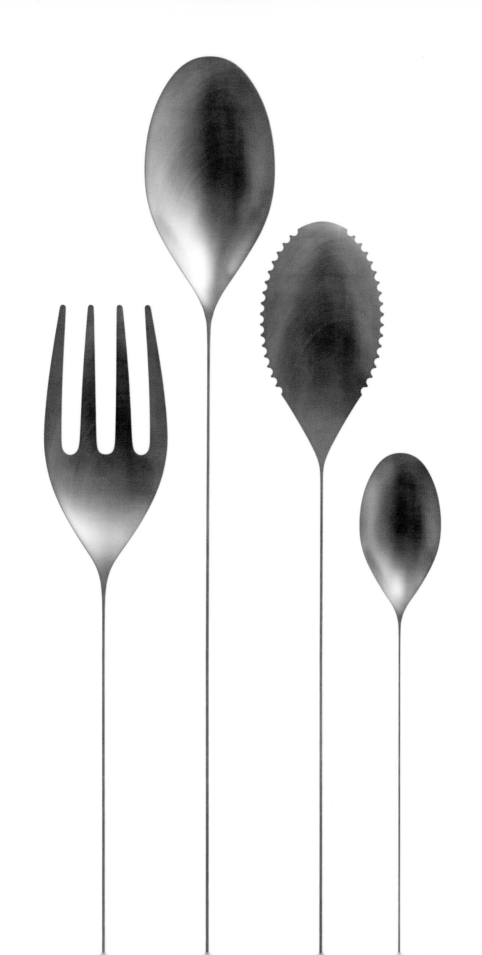

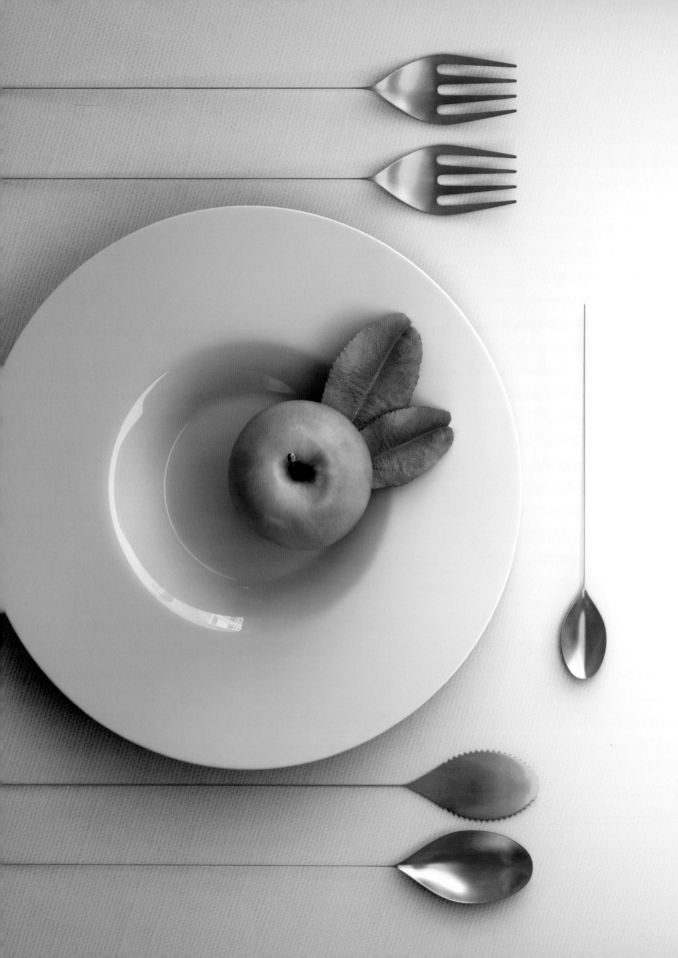

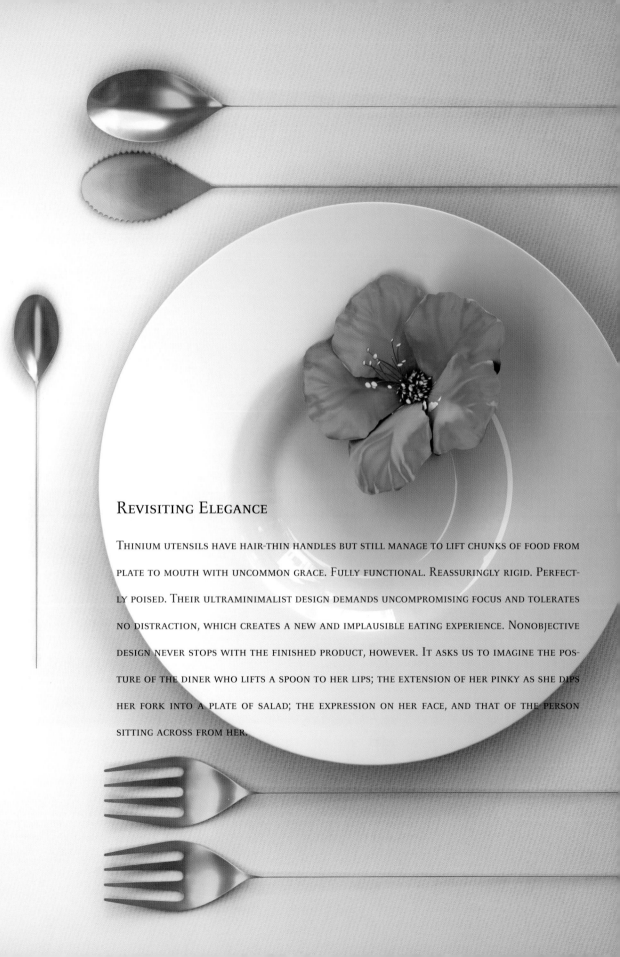

Revisiting Elegance

Thinium utensils have hair-thin handles but still manage to lift chunks of food from plate to mouth with uncommon grace. Fully functional. Reassuringly rigid. Perfectly poised. Their ultraminimalist design demands uncompromising focus and tolerates no distraction, which creates a new and implausible eating experience. Nonobjective design never stops with the finished product, however. It asks us to imagine the posture of the diner who lifts a spoon to her lips; the extension of her pinky as she dips her fork into a plate of salad; the expression on her face, and that of the person sitting across from her.

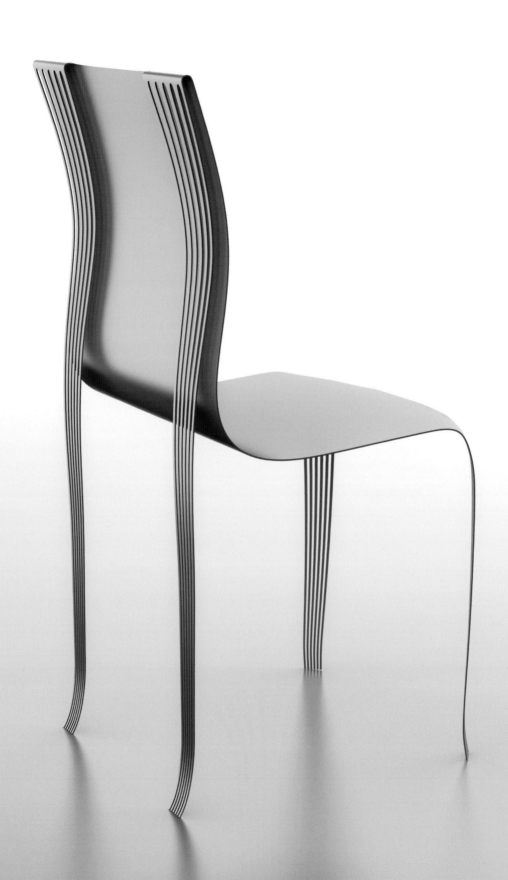

Miss Millimeter Dining Table and Chairs

Imagine the drama of a paper-thin dining chair, exquisitely crafted and extraordinarily sturdy, of a dining table so slender that it disappears when viewed from the edge. Miss Millimeter furniture defies all logic, tests all limits, celebrates all possibilities. As the barriers between possibility and impossibility become permeable, the imagination begins to soar. We'll need only a fraction of the material we now use to furnish our lives. Today's forty-pound table will transform into a table requiring only a few ounces of thinium, and moving it across the room will become child's play. A new interior aesthetic will emerge, and with it a whole new architecture of lightness and transparency.

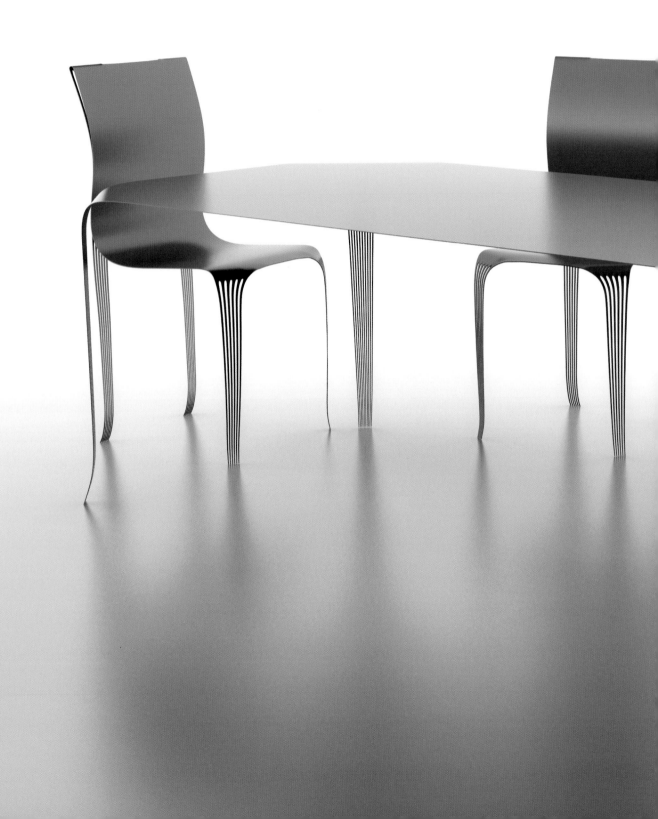

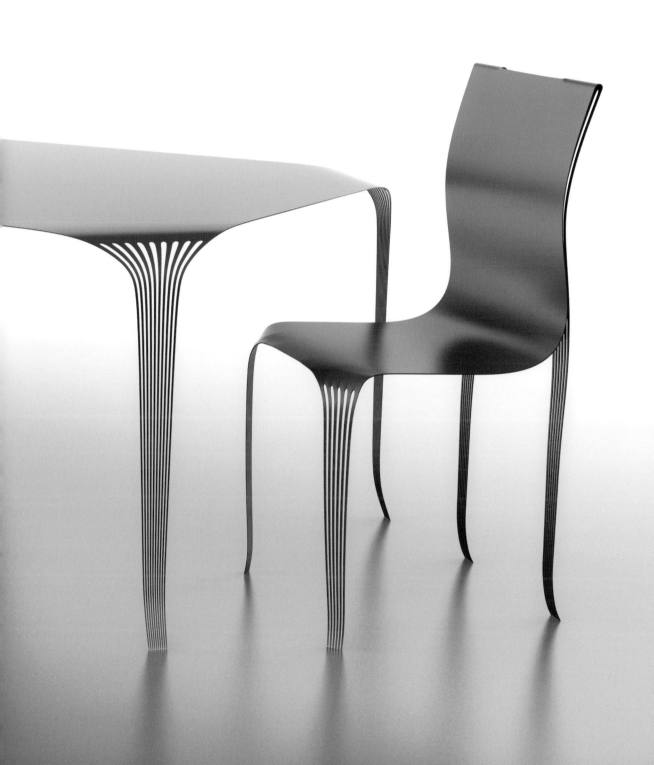

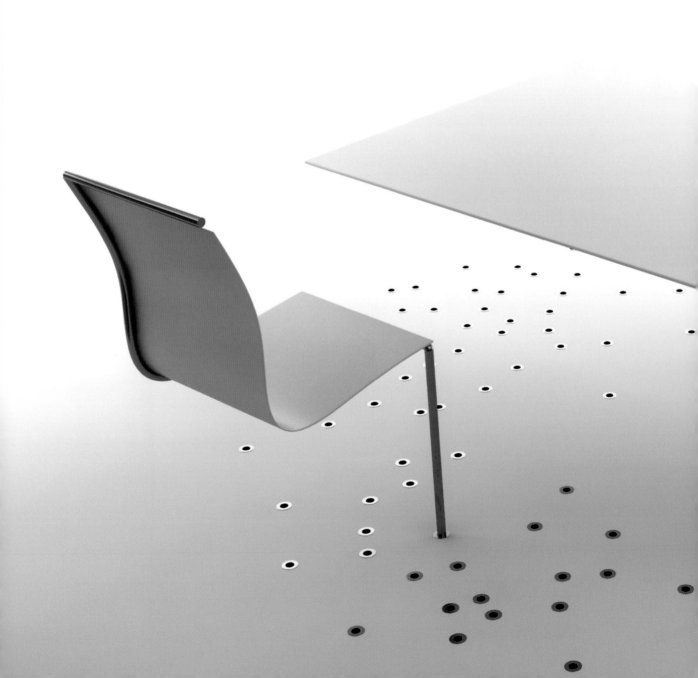

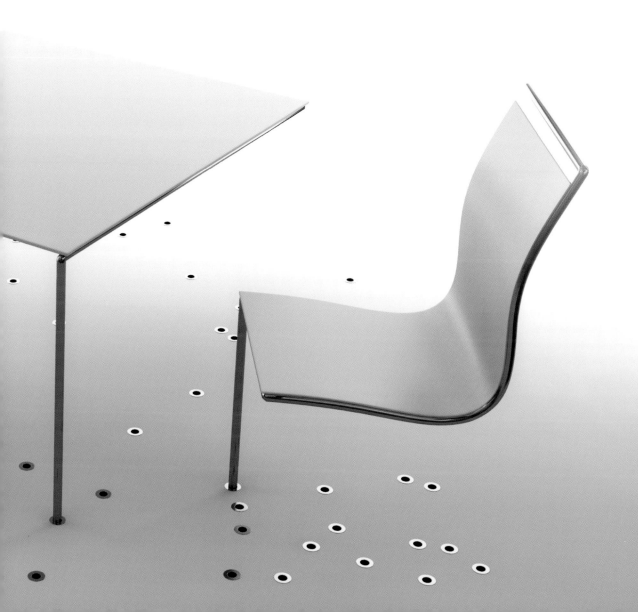

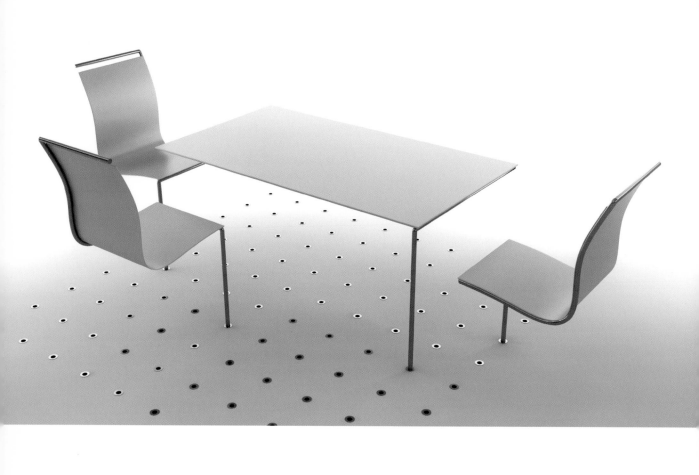
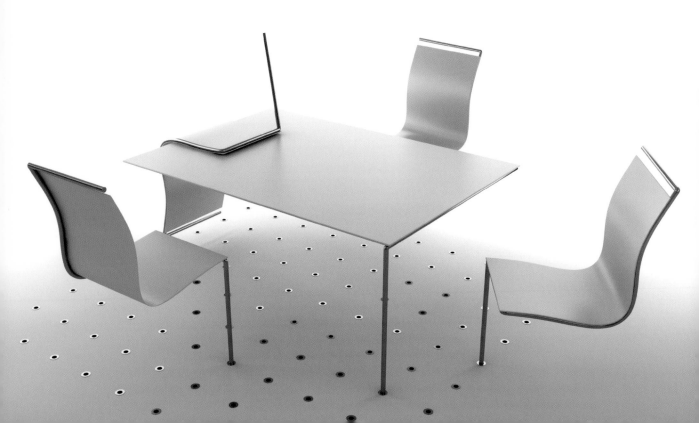

Rush Dinette Set

This dinette set was designed in a rush, and there was no time to attach the remaining legs. This prompted us to look into what happens when we extend the logic of an idea to its outermost reaches. Of course it changes the dynamics of the object, but it alters our perceptions, our expectations, and our behaviors as well. What began as an experiment in "controlled imperfection"—removing one leg, then another, and another—created a dramatically new, asymmetrical geometry and an asymmetrical relation to it. Ettore Sottsass once said of Charles Eames that "he does not design a new chair; he designs a new way of sitting down." Finally, thanks to the miraculous properties of thinium, we are able to realize the fruits of this discovery.

Hardflex Crutch

Hardflex (Hrf, atomic weight 411) is a newcomer to the periodic table. It is a material that, by virtue of its capacity to embody multiple properties, creates extraordinary opportunities for the designer. For nature, miracles like this are all in a day's work, but now, thanks to hardflex, we, too, can evolve products that do not have the same consistency throughout. Here, for example, is a hardflex crutch—soft and yielding where it meets the body but becoming strong and stiff as it advances toward the pavement. Ergonomics disappears or, rather, can for the first time be seamlessly integrated into function, form, and feeling.

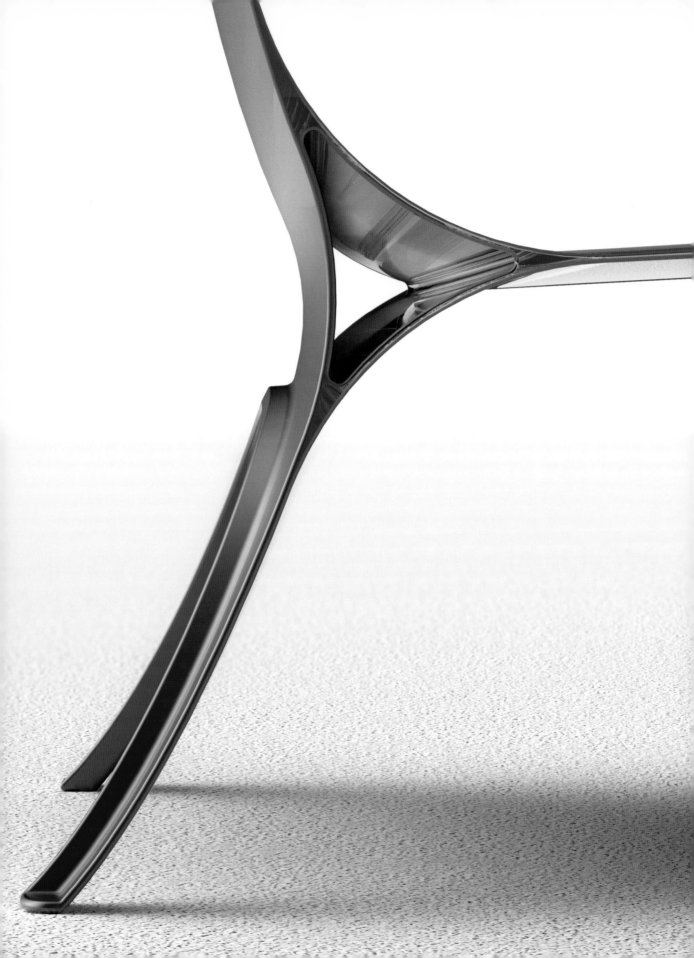

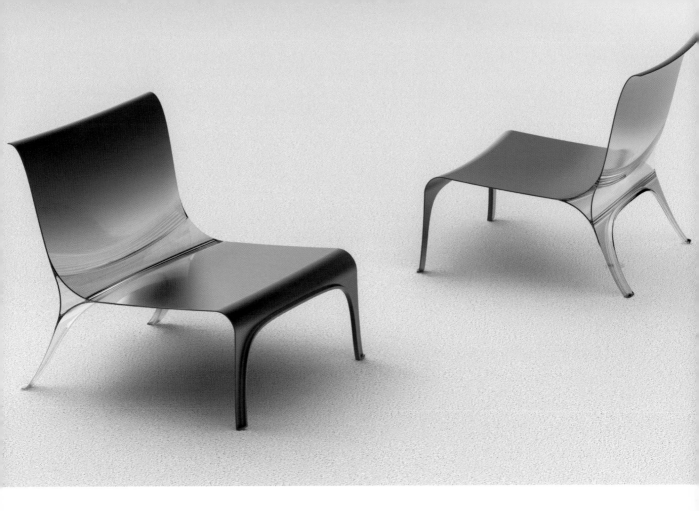

Hardflex Chair

The hardflex chair further explores the properties of this remarkable material, which allow a complete rethinking of industrial manufacturing. Consider: an avocado or a hummingbird begins as a single, undifferentiated cell, which then patiently morphs into all of its necessary structures. We, by contrast, cannot make a simple chair without worrying about rigid frames, soft cushions, and all of the chemical adhesives and mechanical fasteners necessary to assemble it. Hardflex liberates us from the tyranny of all of this pounding and processing. This chair is as hard or as flexible as it needs to be, where it needs to be. Hardflex: material of a thousand nonobjective uses.

The journey *is* the destination.

Rawphisticated

It was the late Claude Lévi-Strauss, gazing upon the savage rituals of the Guaycuru and the Bororo, who taught us how to gaze upon the savage rituals of the Americans and the French. Lévi-Strauss had to venture deep into the jungles of Amazonia to see what had always been hidden in plain sight in our own kitchens and dining rooms.

In *The Raw and the Cooked*, Lévi-Strauss described the poles of the human condition: our roots in the raw pleasures of nature on the one hand and our aspirations for the refinements of culture on the other. These structural poles are connected by a teleology, an anthropology, an ontology that claims that we are drawn inexorably toward the finished state.

It is time to challenge this dualism and the assumptions on which it is based. Why does the destination matter more than the journey? Why is a finished product superior to one that is in progress? At what point did the factory cease to provide the guiding metaphor of culture and yield to the department store? To insist that everything must be perfected before it becomes an object of use or contemplation is to devalue the process that brought it to that state. It freezes time, denies chance, and nullifies the creative act.

Everyone knows that the most profound expression is often captured in the early stage of any art: the notebook sketches of Leonardo da Vinci, the handwritten scores of Beethoven, the annotated manuscripts of James Joyce betray the pathos that lies just beneath the surface of the finished work. Is it possible to preserve the elemental force of the prototype in the completed product?

We set out to recover the human dimension of the things we use—not in the romantic Arts and Crafts sense of celebrating the imperfections of the hand, but by letting mute objects testify to the epic journey that brought them to their present state. Our goal is to peel back their sleek manufactured skins and let their chiseled features and rough edges seduce us into fantasizing about mining and extracting, smelting and refining, manufacture and assembly. No longer will flawed humans face off against the flawless objects

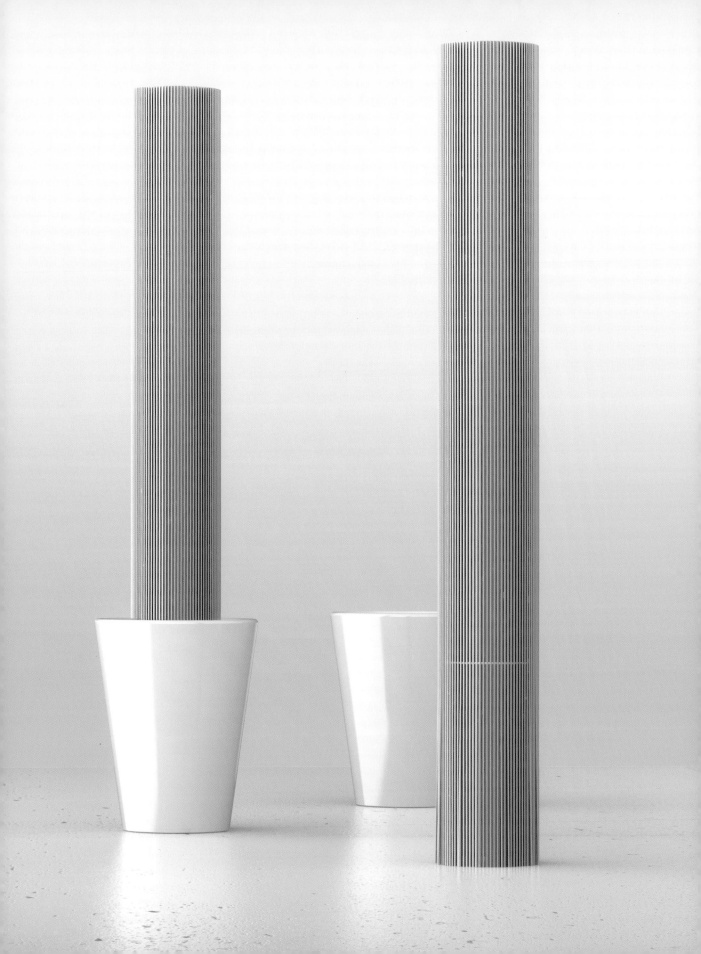

WE OURSELVES HAVE CREATED! WE WILL LEARN TO SEE OURSELVES AS EQUALS, SHARING A CONJOINED HISTORY AND BOUND TO A COMMON FATE.

RAWPHISTICATED NONOBJECTS ALLOW US PARTAKE BOTH OF THE RAW AND THE COOKED, AND—MOST IMPORTANT—OF THE SPACE IN BETWEEN. THEY SHOW US NOT JUST WHAT THINGS DO BUT WHAT THEY ARE AND WHERE THEY COME FROM AND HOW THEY GOT THIS WAY. PERHAPS THEY HINT, COYLY, AT THEIR FUTURE. THEY DO NOT DEMAND OF US THAT WE CHOOSE ONE OR THE OTHER BUT INVITE US TO HAVE BOTH. IN DOING SO THEY DEFY THE STATIC CHARACTER OF EITHER RAW MATERIALS OR FINISHED PRODUCTS AND USHER US INTO A NONOBJECTIVE WORLD OF DYNAMISM, PROCESS, AND FLOW.

T BRUSH

THE T BRUSH COMBINES THE MOST REFINED AND THE MOST ELEMENTAL, THE SUBLIME EXPRESSIONS OF HUMAN DESIRE AND THE BASE EXCRETIONS OF MATERIAL NEED. CLEANING A TOILET BOWL IS A LEGITIMATE TASK, SO WHY NOT TREAT IT AS A DESIGN OPPORTUNITY? THE T BRUSH TAKES AN UNSAVORY CHORE AND ASKS HOW IT MIGHT BE ENHANCED, AUGMENTED. IT IS A BRUSH WITHOUT A HANDLE, A BRUSH THAT IS ALL HANDLE, AN IMPLEMENT THAT MOCKS OUR NEED TO DISTINGUISH BETWEEN THE USER END AND THE BUSINESS END. IT IS ALL BRISTLE. THE JOURNEY FROM FIBER TO FIBER IS COMPLETE.

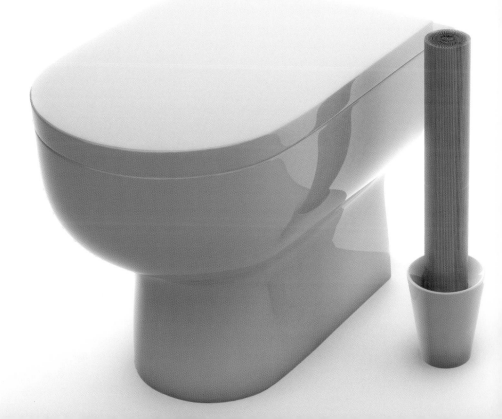

Rawphisticated Cell Phone

This cell phone exhibits a deliberately unfinished finish. There is tension between its roughness and smooth realization, but isn't this a more honest representation of life and how we live it? No orange is a perfect sphere; no tree grows in a perfectly straight line. Why then do we seek perfection in our lives and in our objects? The rawphisticated phone plays with the real world of being and becoming and refuses to privilege either the unfinished or the perfected state. It comes out of your pocket dog-eared and wrinkled, like a business card would, or rough and chiseled, revealing the hand of the sculptor.

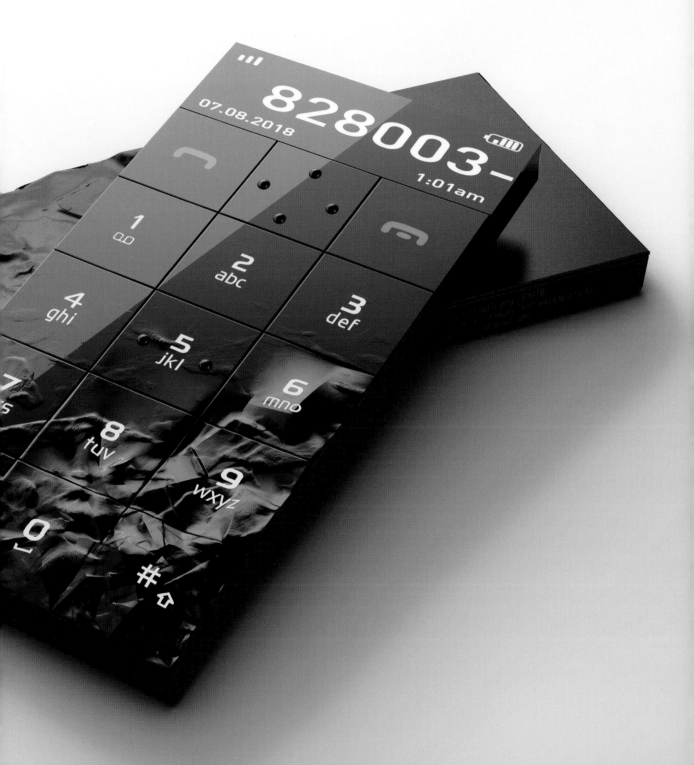

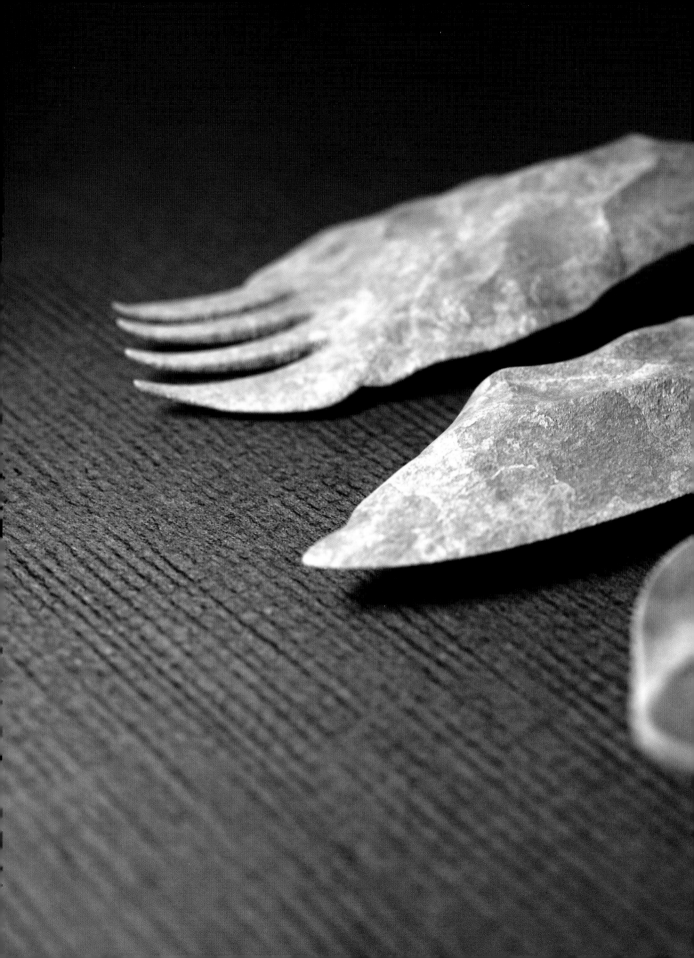

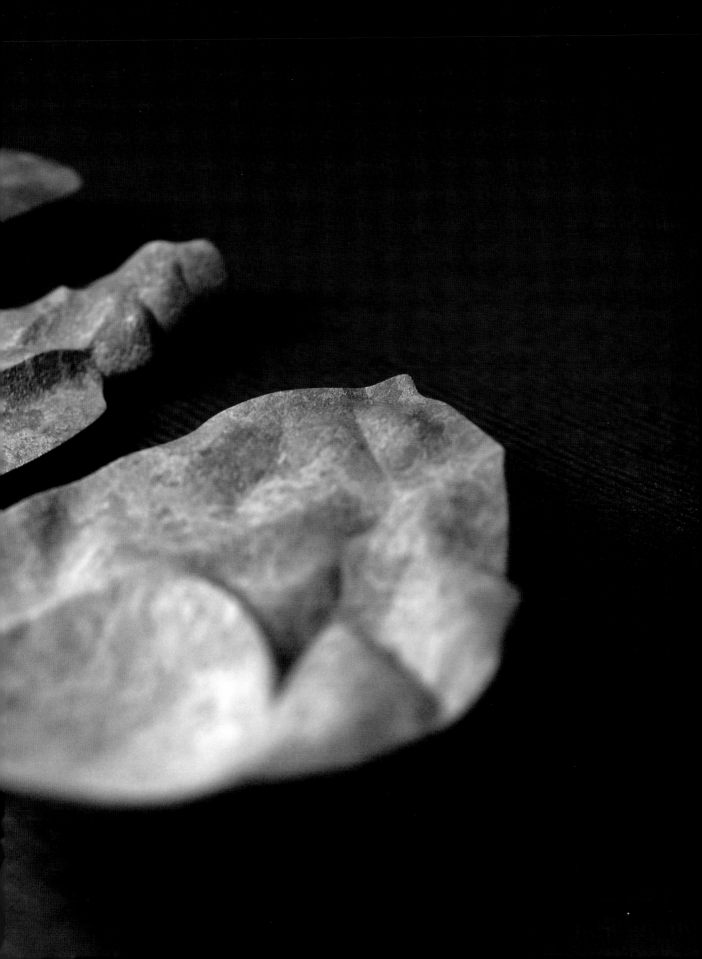

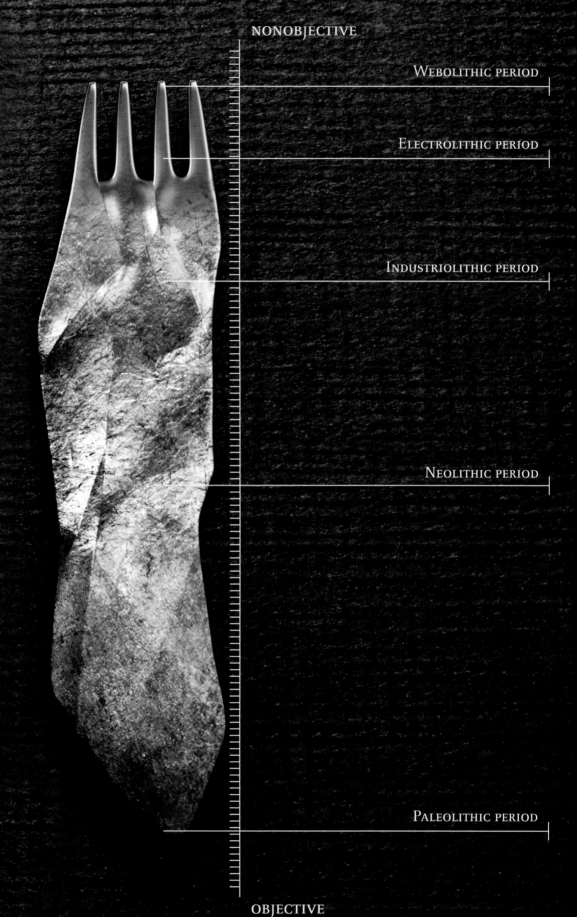

NONOBJECTIVE

WEBOLITHIC PERIOD

ELECTROLITHIC PERIOD

INDUSTRIOLITHIC PERIOD

NEOLITHIC PERIOD

PALEOLITHIC PERIOD

OBJECTIVE

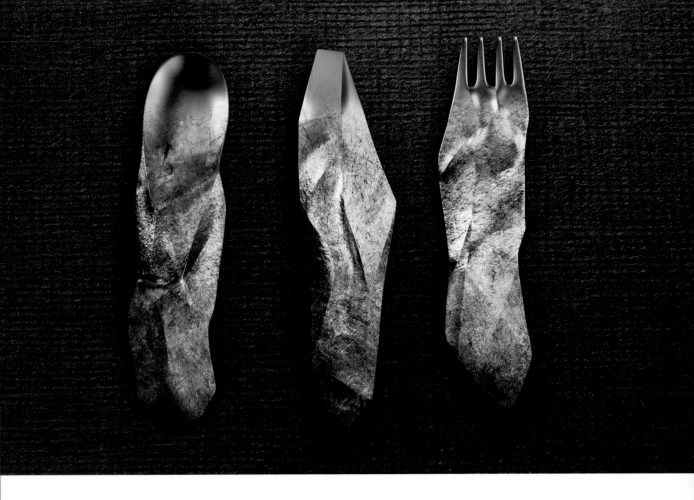

Paleoware

Here, finally, is a set of hand tools that for the first time takes the human legacy of toolmaking seriously. Rather than repudiate our inglorious past in the name of "innovation," Paleoware acknowledges every stage in the history of its own genre of technology. The user end recalls a bifacial Acheulean hand ax, fitted to the form of the human hand by thousands of years of biotechnical coevolution. At the business end is a state-of-the-art implement that performs its ancient tasks—pounding, scraping, measuring—with the functional precision we expect from today's best tools. To use a Nonobject from the Paleoware toolbox is to celebrate our continuing ingenuity.

"The sight of immediate reality," wrote Walter Benjamin, "has become an orchid in the land of technology."

NATURA

The charming thing about Nature (bless her heart) is that she is completely unpredictable. She will rage against us with unrelenting fury and then, just when we think we cannot take it any more, bathe us in warm sunlight and a fragrant breeze. Her outbursts frustrate our plans and betray our expectations, but we love her for them only that much more. "Nothing is harder to bear," mused Goethe, "than a succession of fair days."

We turn to the inconstancy of nature for relief from the predictability of modern industry. In nature no two things are ever completely alike, and the same was true, for the bulk of human history, of the work of the hand. Bricks, coins, horseshoe nails, and (much later) printed pages were practically the only things produced in multiples. In the blink of an eye, this millennial regime was turned upside down, and we have spent the last century and a half coping and failing to cope with this historic inversion.

According to the logic of industry, even the slightest variation is a flaw. A daydreaming worker in Shenzhen might put the handle on backward, and a quality-control inspector in Stuttgart might look the other way in return for a handsome bribe, but these are the exceptions that prove the fabled rule. For the most part, it does not matter which can of tennis balls, which pair of jeans, or which holiday cruise you buy off the shelf. Every one is as nearly as possible identical to the one that came before and the one that comes after, and that is the point. This is how, slowly but surely, we lost our connection to nature.

How strange it would be if every cloud in the sky had the same regularity as a roll of wallpaper. Or if every tree in the forest was perfectly symmetrical and grew to

EXACTLY THE SAME HEIGHT. BUT NOW IMAGINE JUST THE OPPOSITE: WHAT IF CONSUMERS COULD CHOOSE FROM AN ENDLESS ARRAY OF PRODUCTS, EACH WITH ITS DISTINCT SHAPE, SIZE, AND TEXTURE? THIS IS THE NEW GENUS NATURA, FLORA AND FAUNA OF THE NONOBJECTIVE WORLD THAT DO NOT PARTAKE EITHER OF THE CHARM OF THE CRAFT FAIRE OR THE SWINDLE OF PLASTIC FERNS AND FAUX LEATHER. NATURA NONOBJECTS RESTORE THE LINK BETWEEN THE PRODUCTS OF NATURE AND THE PRODUCTS OF INDUSTRY BY RECONNECTING US WITH THE BEWILDERING DIVERSITY THAT DEFINES BOTH NATURE AND OURSELVES.

Pebble Media Player

The internal components of this MP3 player are manufactured according to the most exacting technical specifications, but that is where the resemblance to today's tedious commodities ends. At present, products on the shelf differ from one another at most by the whims of color or feature set. If we could introduce an element of biodiversity into the production process, we could fundamentally transform the experience of consumption. The shelves of our department stores would offer up their bounty like baskets of heirloom tomatoes at a farmers' market. An electronics store would display its MP3 players in buckets, glistening like wet pebbles picked up on a beach.

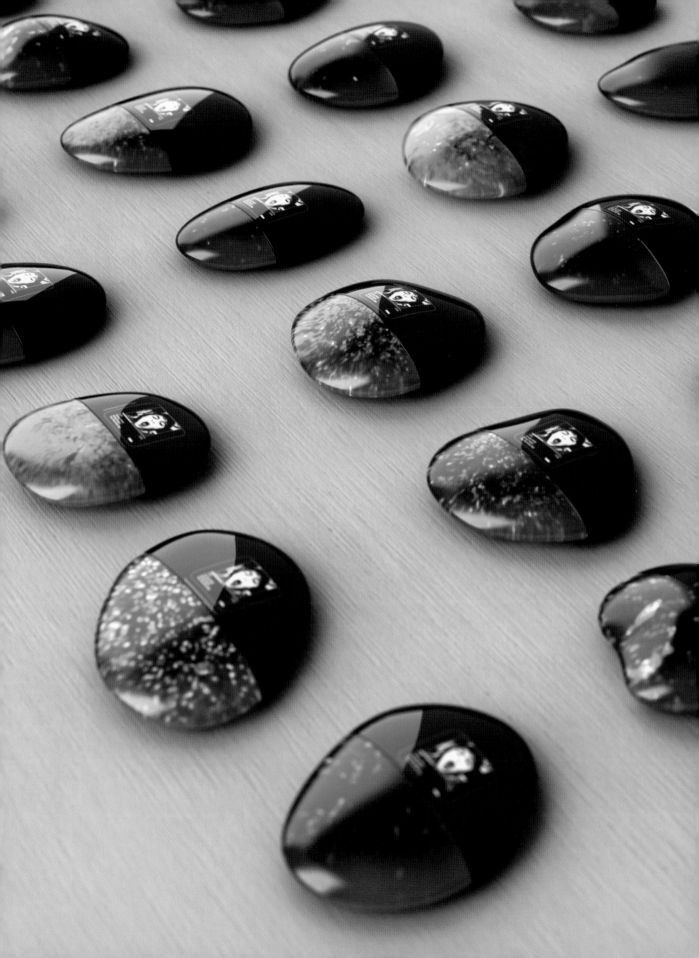

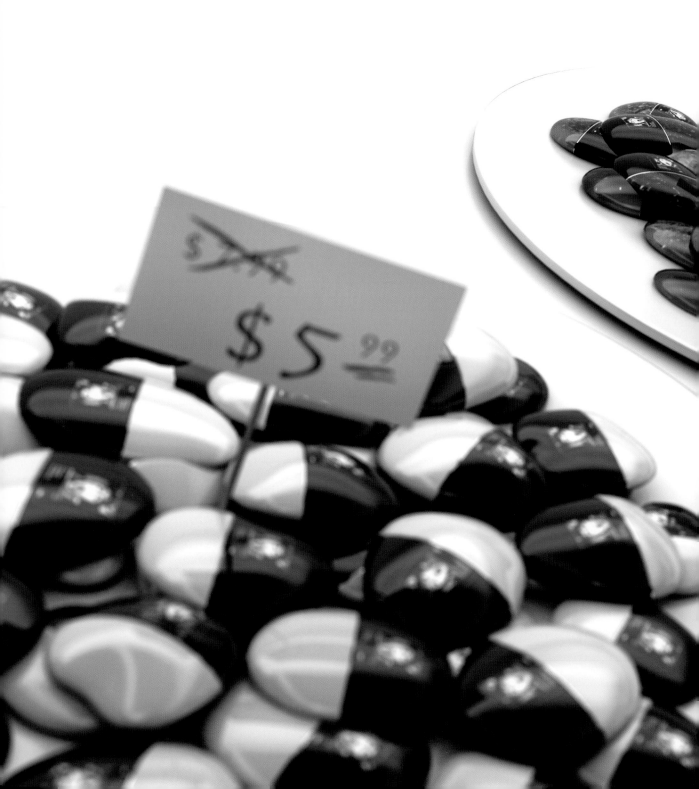

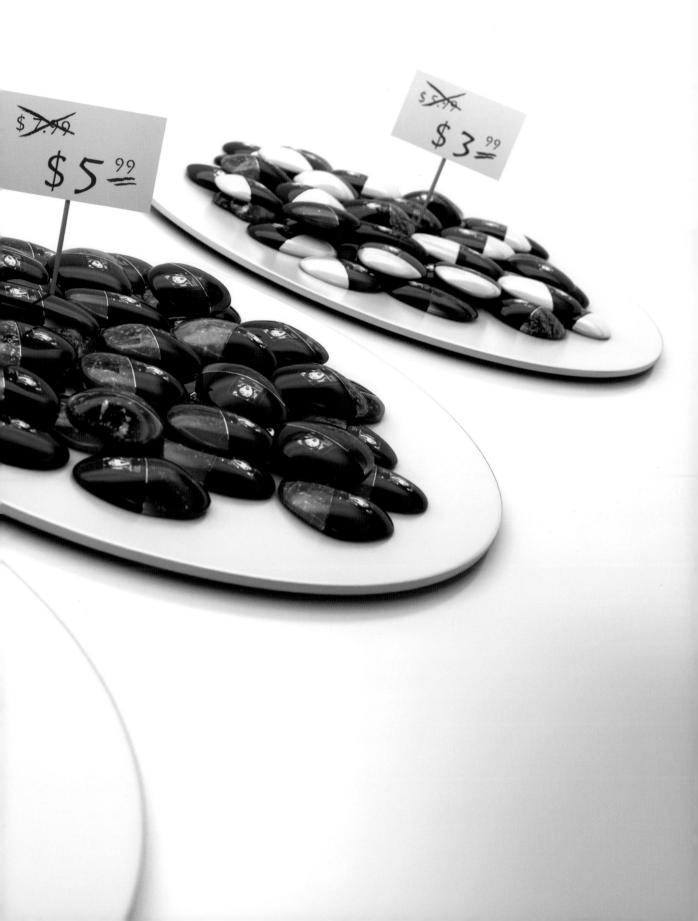

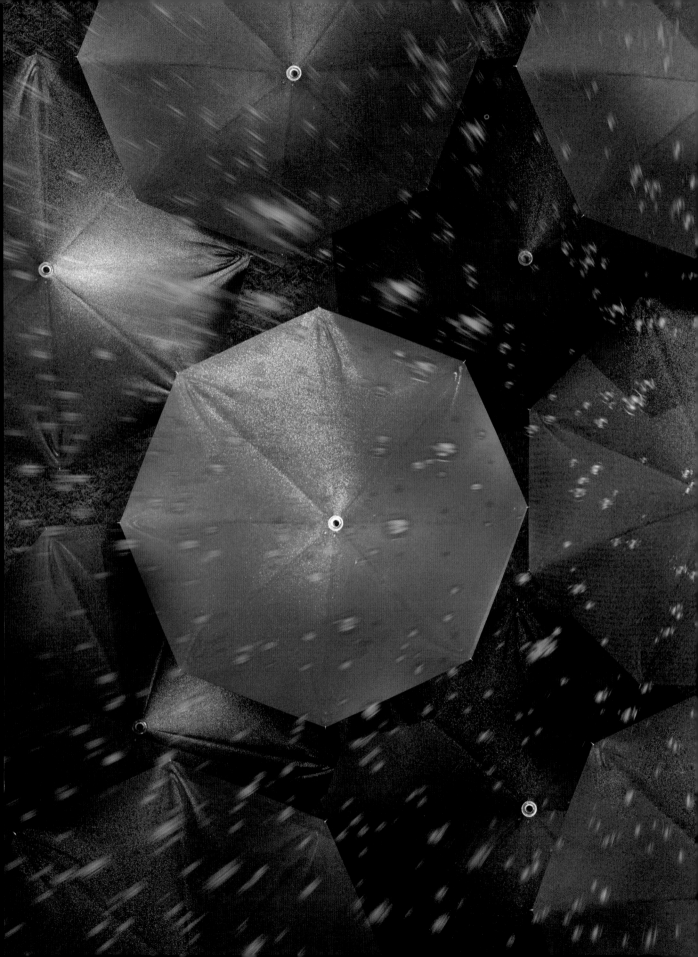

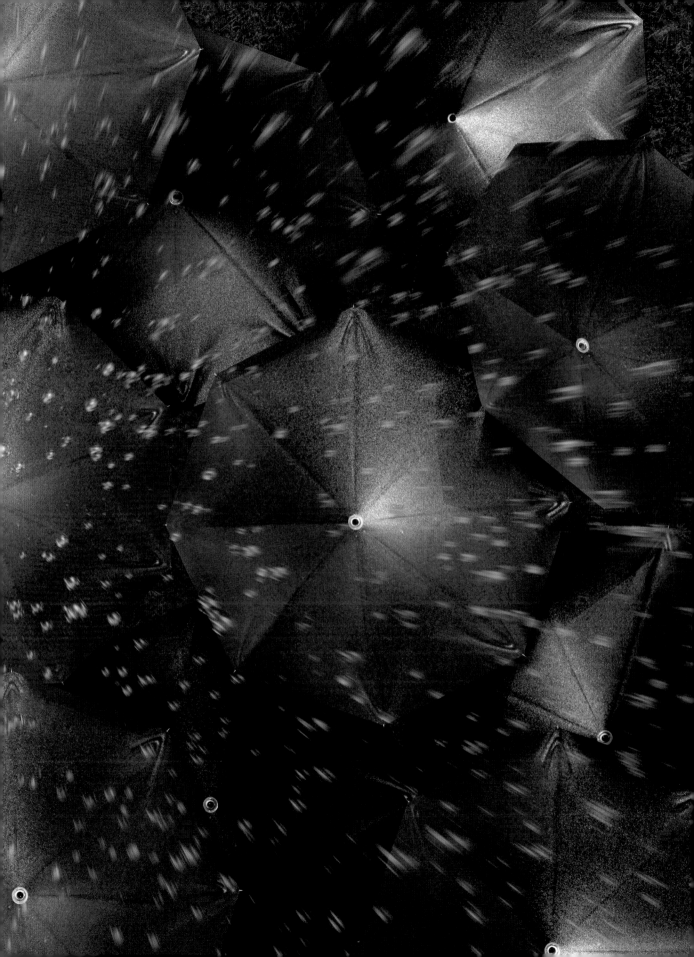

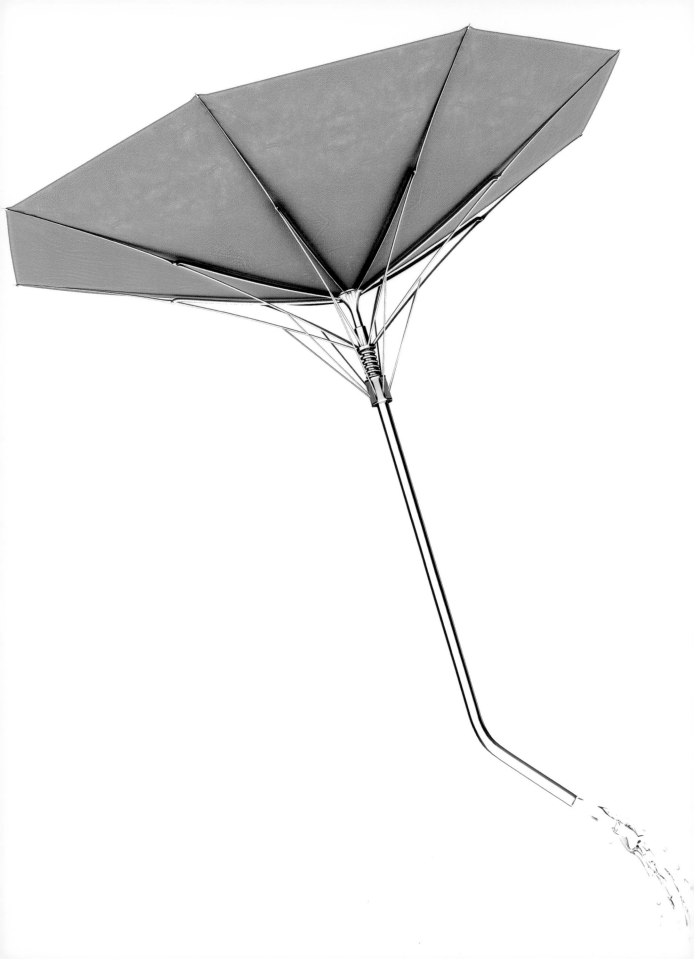

KISHA UNbrella

ALL PRODUCTS SERVE, IN ONE WAY OR ANOTHER, TO PROTECT US FROM THE ELEMENTS, BUT BY SEPARATING OURSELVES FROM NATURE WE BECOME SEPARATED FROM OURSELVES. TAKE THE HUMBLE UMBRELLA. IT SHELTERS US FROM THE RAIN, BUT THIS IMPLIES THAT THE RAIN IS OUR ENEMY, A HOSTILE FORCE FROM WHICH WE NEED TO BE PROTECTED. KISHA BRINGS US INTO A DIFFERENT KIND OF RELATIONSHIP WITH NATURE. ITS UPTURNED, WINDPROOF FORM REACHES UP LIKE A FLOWER TO CAPTURE THE FALLING RAIN, AND ITS HOLLOW HANDLE DIRECTS IT WHERE IT NEEDS TO GO. THE RAIN NOURISHES THE FLOWER, REMINDING US THAT WE NEED NOURISHING TOO.

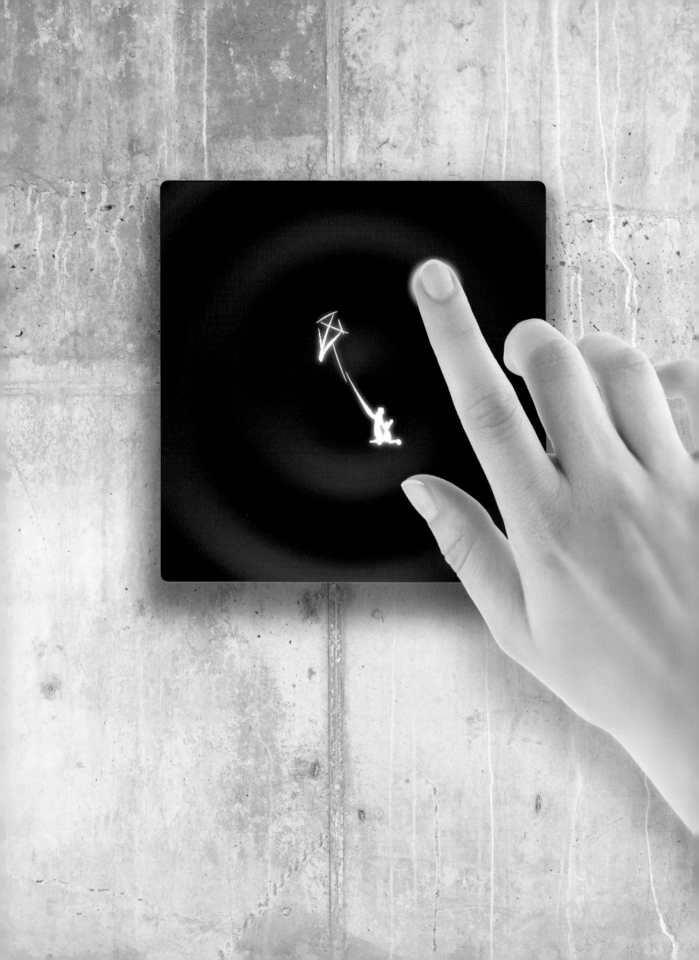

Climatology

Air conditioning controls our indoor environments, and it has succeeded all too well: it has taught us to quantify comfort, to translate well-being into degrees of Celsius and Fahrenheit. They are techno-centric rather than human-centric criteria, database supported, not emotionally supportive. They warm us up and cool us down with no relation to natural weather systems or even to our own nuanced desires. The nonobjective user interface of this thermostat challenges us to do better. It invites us to choose not just the temperature but also the climate that suits our mood. Fresh sea air, a balmy summer breeze, a crisp wintry morning, or the nervous calm before the storm.

6° c -2° c 7° c

22 c 18° c 19° c

12.5° c 25° c 21° c

17° c 16° c 28° c

User interface today

User interface tomorrow

WATER BOOKS

OUR BODIES THIRST FOR WATER, AND OUR MINDS ARE THIRSTY FOR KNOWLEDGE; FINALLY WE CAN SATISFY BOTH NEEDS AT ONCE. WATER BOOKS TELL A WHOLE NEW STORY ABOUT HYDRATION. ARE YOU IN THE MOOD FOR FICTION? BIOGRAPHY? ADVENTURE, OR ROMANCE? PERHAPS YOU'D LIKE TO IMBIBE A TECHNICAL TREATISE ON THE HEALTH OF THE POLAR ICE CAPS? EVERY DAY YOU CHOOSE A BOOK-SHAPED BOTTLE, FILLED TO THE BRIM WITH PRECIOUS H_2O. THEN IT'S UP TO YOU TO SIP A FEW PAGES OR GULP DOWN AN ENTIRE CHAPTER. NO MORE PLASTIC WATER BOTTLES TO LITTER OUR LANDFILLS. AND NO FOOTNOTES.

"I have never been forced to accept compromises," insisted Charles Eames, "but I have willingly accepted constraints."

90 Degrees

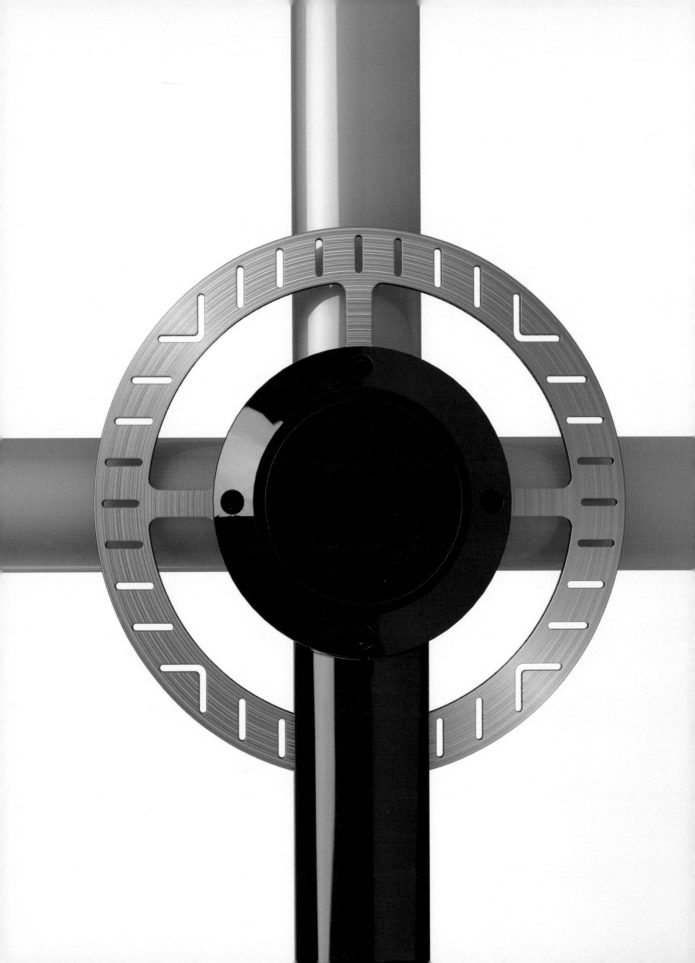

One of the masterpieces of modern logic, poised midway between Lewis Carroll's *Through the Looking-Glass* (1872) and Ludwig Wittgenstein's *Tractatus Logico-Philosophicus* (1921), is Edwin A. Abbott's classic, *Flatland* (1882). In his charming "Romance of Many Dimensions," Abbott described a planar, two-dimensional world inhabited by female line segments and regular male polygons who live out their lives along an x-y axis.

The narrator, A. Square, first ventures out from his native Flatland to one-dimensional Lineland where he vainly attempts to explain the concept of dimensionality to an uncomprehending population of "lustrous points." But then he himself is visited by an emissary from three-dimensional Spaceland and must struggle to grasp the concept of the sphere. With sparkling wit and rigorous mathematical consistency, Abbott provides an ideal introduction to the nonobjective Rule of 90 Degrees.

We propose here a family of Nonobjects conceived around a single design principle: Every part, and the connection between every part, must be based on the right angle, and we extrapolate from there. How would this principle alter the form of a table fan or a stethoscope or a helicopter? How would it affect their function? How might our social relations, as mediated by our relation to our objects, be reconfigured by the Rule of 90 Degrees?

By deliberately submitting to a seemingly arbitrary geometrical constraint, we impose upon ourselves a rigorous logical discipline and explore the full range of ergonomic consequences. We heighten our consciousness of the constraints imposed by the everyday world, and this is what is truly liberating. Design is not about escaping from constraints. It is about mastering them.

But the journey of discovery can be risky. Only by opening ourselves up to the possibility of other dimensions can we discover the limits of our own, and this proves to be a dangerous business. Like Plato's philosopher, who escapes the darkness of the cave with a burning desire to enlighten his ignorant countrymen, A. Square endeavors to persuade his fellow Flatlanders that their world is larger, richer, and more dimensional than it seems. And like Plato's Socrates, his efforts land him in the slammer, his vision dismissed as "the offspring of a diseased imagination, or the baseless fabric of a dream." We trust that the followers of the Rule of 90 Degrees will have better luck.

RIGHT

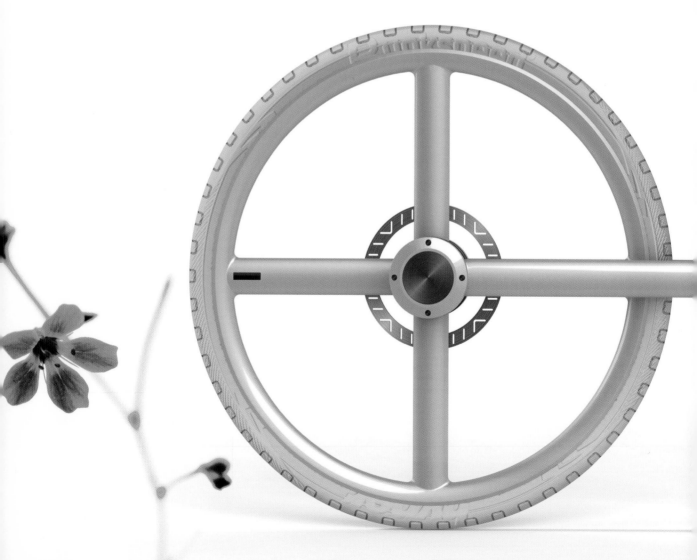

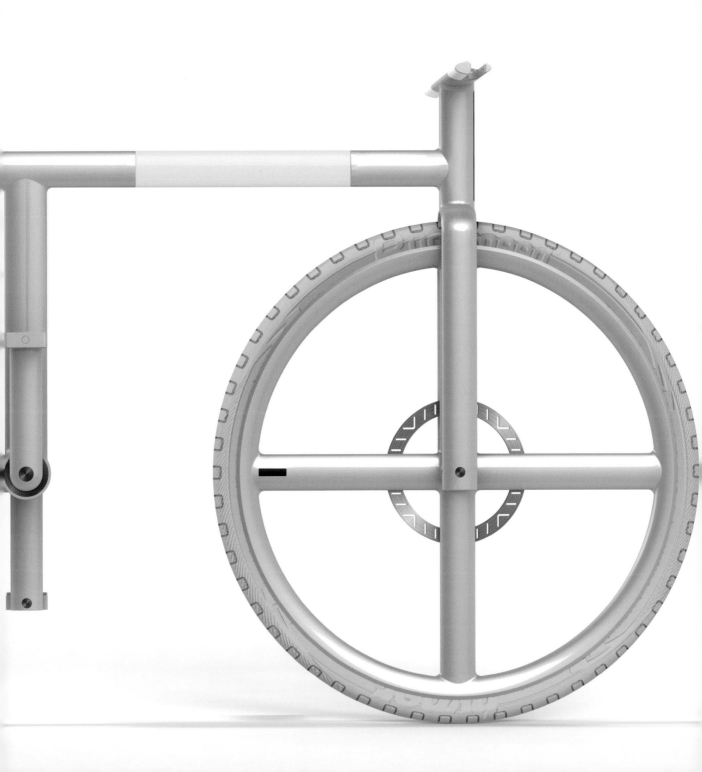

Right Bike

Driven by the Rule of 90 Degrees, a defiant attitude toward "how it's supposed to be done," and a touch of nostalgia for the Italian push-bike of times gone by, Right Bike has a look that is entirely its own. The frame, of course, is constructed out of nonobjective thinium, and the saddle, made of fully recyclable hardflex, offers a balance between comfort and support that no objective alloy could provide. Created neither for road nor for mountain, Right Bike has no useless features or accessories but contains everything that is needed for a perfect ride. It is designed in reference to pure geometry and manufactured according to strict mathematical law.

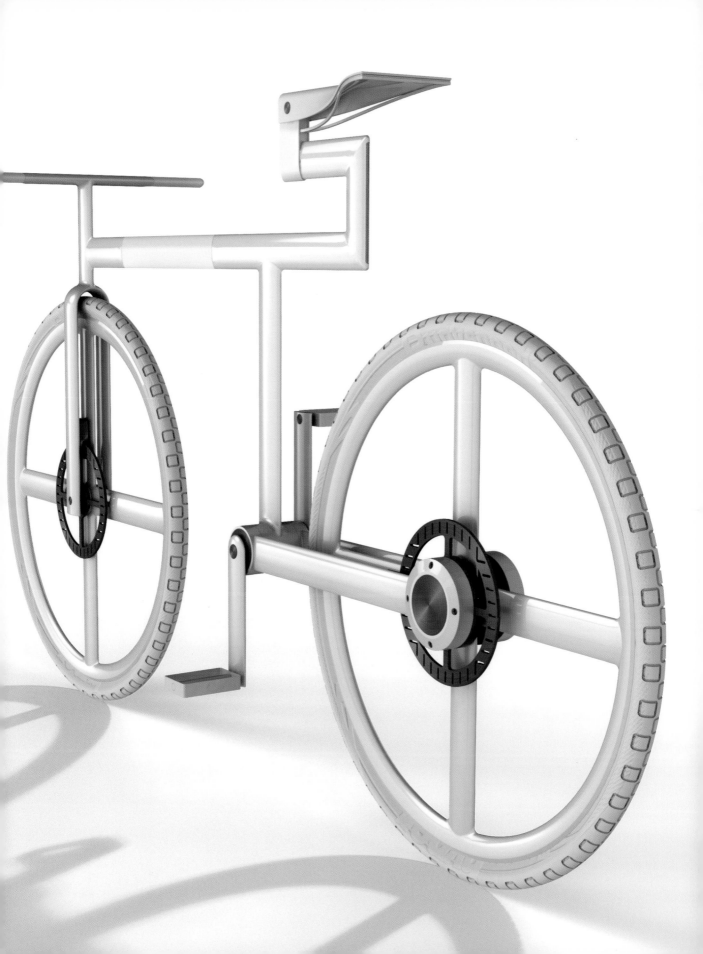

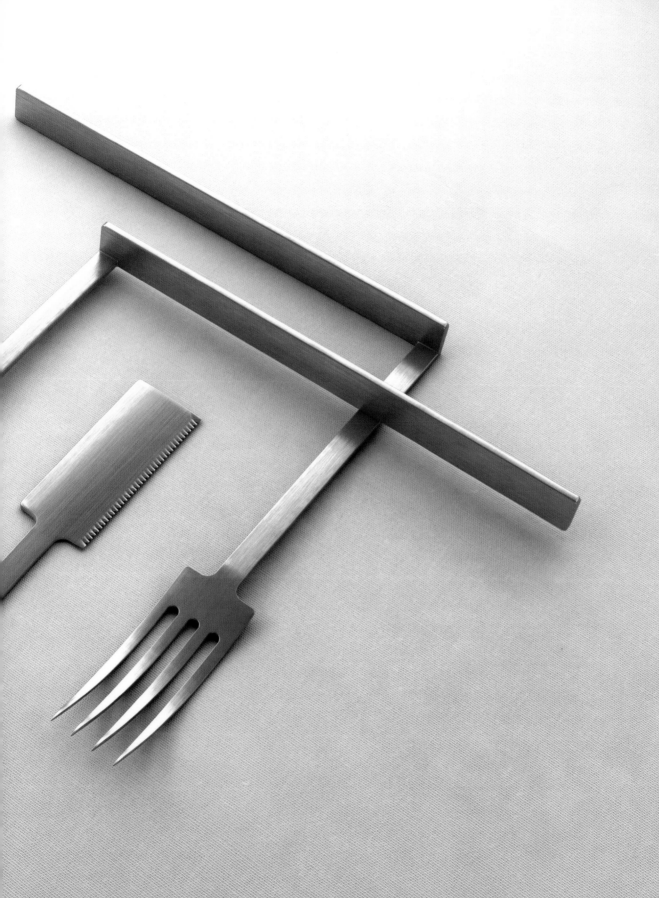

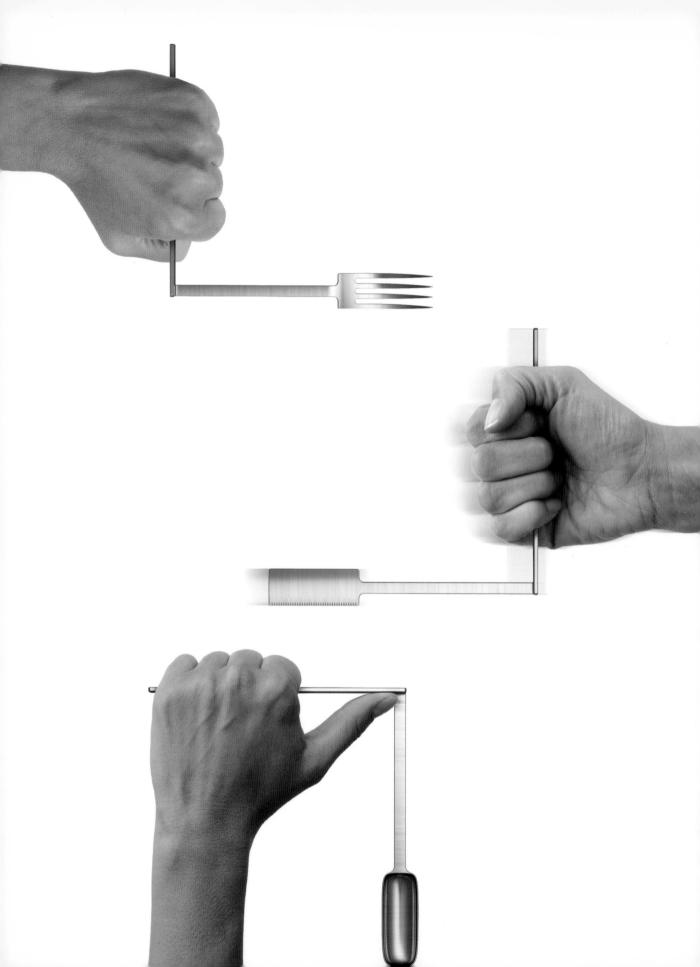

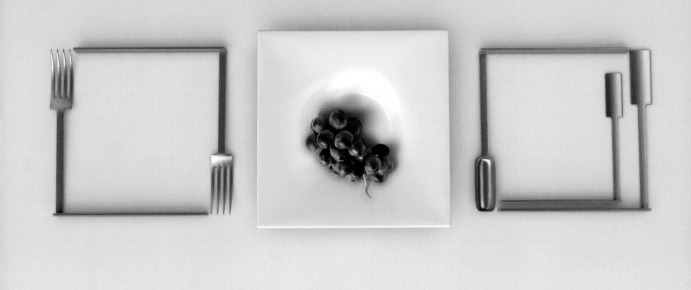

Rectilinear Elegance

There is a dynamic relationship between utensils and how we hold them: to a greater extent than we may care to admit, we are more likely to adjust ourselves to our tools than the other way around. Imagine a romantic candlelit dinner, or a family picnic, or a formal banquet in which all of the utensils were crafted according to the Rule of 90 Degrees. Surely our physical gestures and spatial relationships would change, and we would experience a different relationship with the food we are eating. But would we evolve an entirely new set of manners? Would we speak differently to one another, and about different things?

Right Stapler

Daily life consists of an endless series of microdecisions, most of them so trivial that we are not even aware that we are making them, and each of them creating the potential for time loss and stress. But not so fast! Every choice we make—shall I put on my left shoe first, or my right? Should I fasten my seatbelt first and then lock the door, or the other way around?—requisitions a few neurons and claims a few seconds, and they add up. The Rule of 90 Degrees can free up valuable time that can be applied to philosophy, politics, piano lessons, or coaching a Little League team. We no longer need to tax our intellectual resources deciding whether to position our staplers at the top of a stack of documents or to the side. Consistent results, every time.

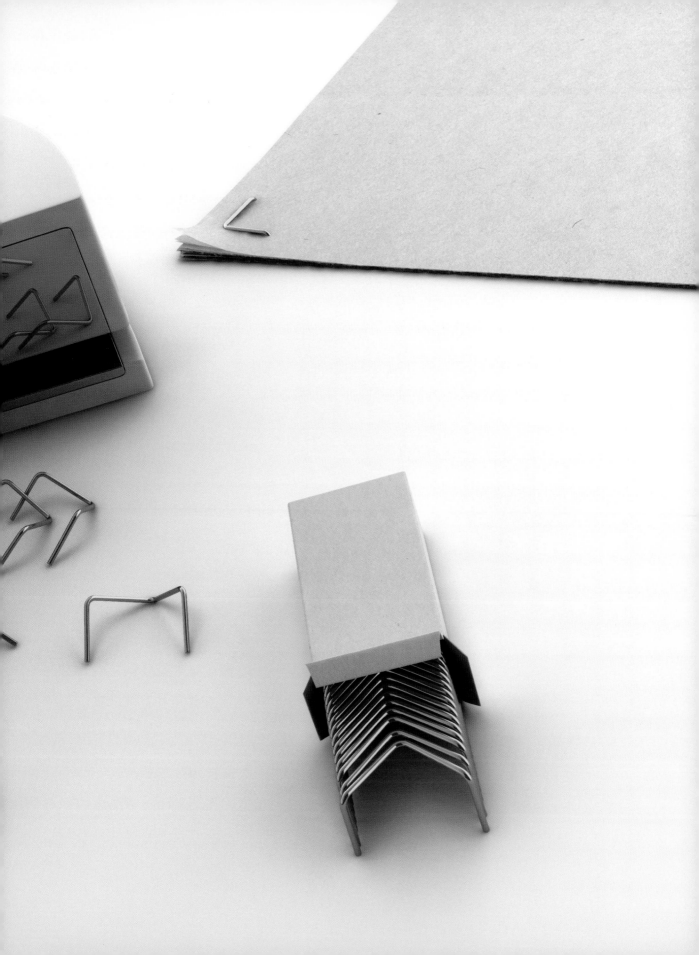

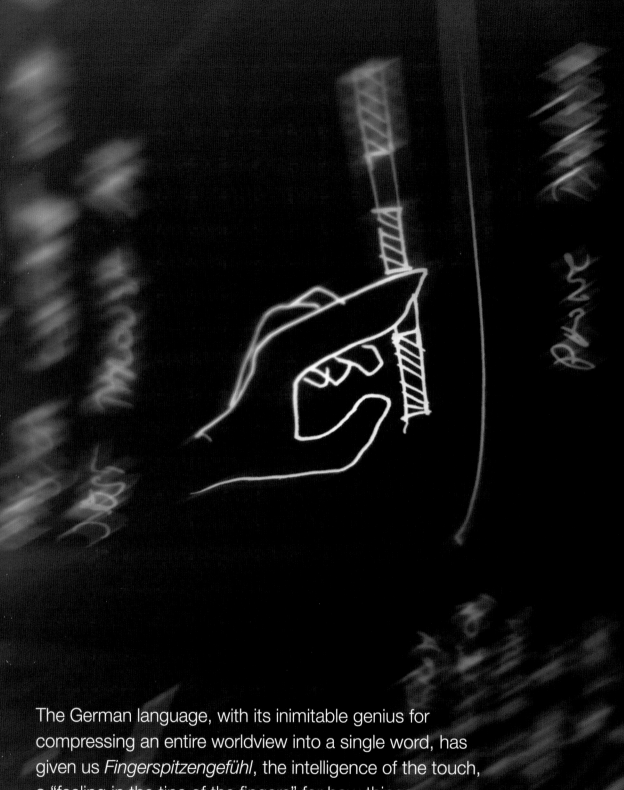

The German language, with its inimitable genius for compressing an entire worldview into a single word, has given us *Fingerspitzengefühl*, the intelligence of the touch, a "feeling in the tips of the fingers" for how things should be done.

TOUCH

Vilém Flusser, the great Czech-Brazilian communications theorist, was the first to discern human adaptation to postindustrial civilization: "This new human being in the process of being born all around us and within us is in fact without hands." Since he no longer needs to manipulate physical objects, "the only thing left of his hands are the tips of his fingers, which he uses to tap on keys so as to play with symbols."

Thus the most ancient emblem of civilization is vindicated: the mythology of King Midas, whose golden touch conjured the chimera of instantaneous wealth; the theology of Michelangelo, who captured the electric moment of creation on the ceiling of the Sistine Chapel; the ideology of the Cold War, whose finger-on-the-button imagery traumatized Margaret Mead and an entire generation of baby boomers. The atrophied citizens of the *digit*-all age, who sit in virtual offices, take virtual vacations, and dream (incongruously) of virtual sex, are the logical outcome of the relentless displacement of the work of the hand by the life of the mind. All we can do is point our fingers accusingly at myriad keys and buttons and touch screens, hoping that something will happen.

Does it have to end this way? Is it possible to redeem the sense of touch and restore it to its rightful place as the vanguard of experience, rather than its last, pathetic remnant? This is the goal of the Touch series of Nonobjects. They seek to celebrate the most deliberate, the most intentional of our senses. Unlike the objects of sight or sound or smell, which are thrust upon us whether we want them to be or not, we decide whether or not to touch, to hold, to pick up and put down. Our fingers—to a greater extent than our eyes, our ears, or our noses—give us access to the physical and metaphysical universe. They are the link, neurologist Frank Wilson has argued, between the brain, language, and culture. They deserve greater respect than design-ers have given them.

The finger is an amazingly complex and dignified adaptation: the fingertips, with their delicate loops and whorls and tented arches; the fragile biomechanical link-ages of flexors and tendons; the tough keratinous nails, embarrassing reminders of the claws, hooves, and talons of lower orders. Let's celebrate the agent, and the act, of touch. Let's restore this sensitive structure to its central role as the leading edge, the point of contact between ourselves and the world we have created.

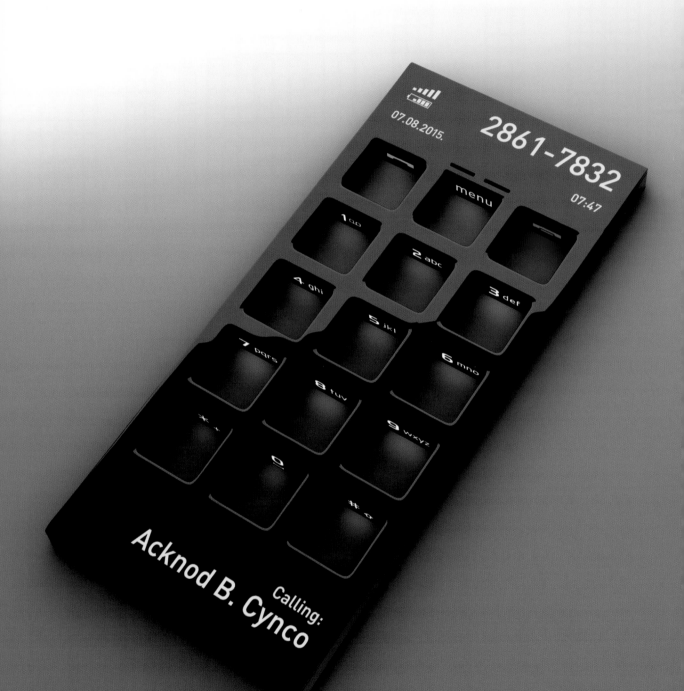

Tarati touchless

Tarati, from the Sanskrit meaning, "he who passes through," gives us our words *transient, transistor, and transition*. It is a premodern link to our postmodern world of hypermobility, and it exposes the stupidity of even the smartest of today's smart phones. Without exception, they are solid, opaque, a barrier separating *I* and *Thou* rather than a permeable membrane connecting us. The Tarati cell phone restores the magic. It enables the caller to connect with others by passing the fingers through the keypad rather than jamming them into it. Tarati invites us, finally, to "reach out and touch someone" through the invisible magic of technology. It is, literally, poetry in motion, the first step toward realizing the promise of cellular technology. Technology, invisible as it is, is also magical. It is possible to penetrate the barrier of the physical.

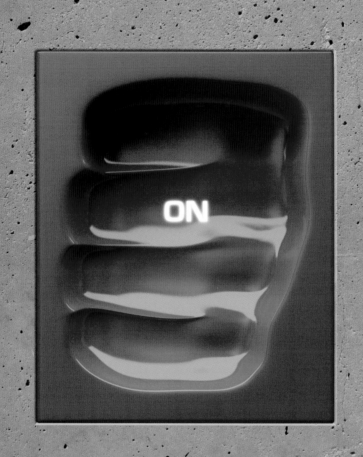

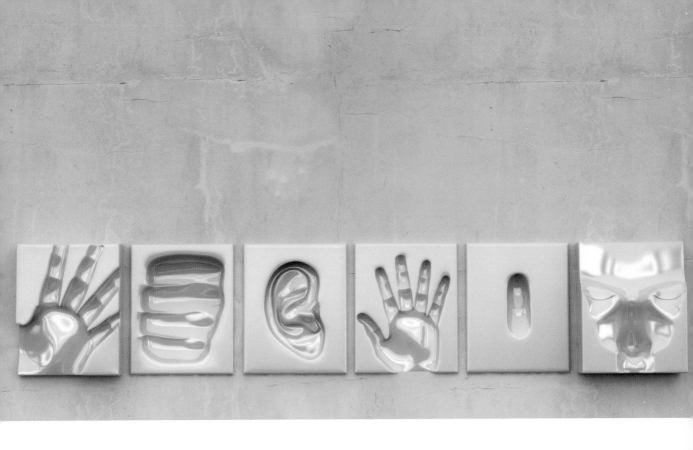

enLighten Switch

Even with the wide range of fixtures and fittings available to us, the sterility of the modern home is shocking. We snap a light switch into the on or off position with scarcely a thought to the biblical proportions of our deed: Let there be light! Instead of reeling at the cosmic act, we perform it with indifference, an indifference that extends from switches to walls to the whole of our prefab environments. The enLighten switch incites the revolt. It allows us to personalize our homes in a way that IKEA never will. Punch the wall if you are angry. Lean your hand into it for moral support. Stab your index finger into it for emphasis. Engage your own home in a new and active way.

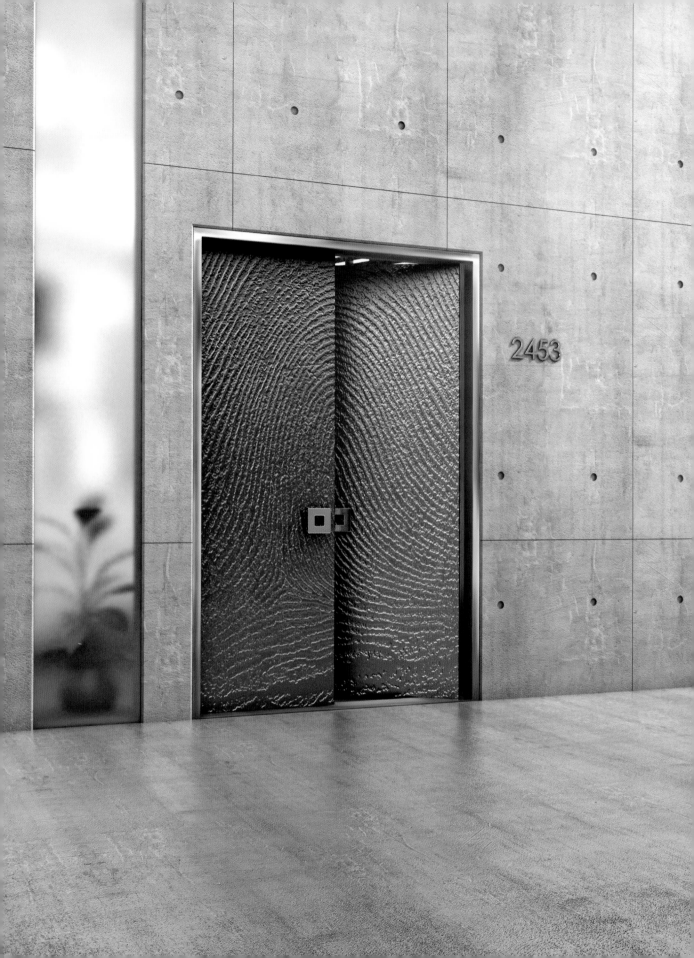

Human Grain Door

In recent years we have begun to see fingerprint scanners control access to office buildings, laboratories, and high school examination rooms, but they always carry the intimidating aura of the state security apparatus. We want to explore a friendlier, more welcoming interpretation. Imagine being able to personalize your front door with your own inimitable fingerprint, expanded to a scale where it can be appreciated in all of its biometrical glory. When the quaint but meaningless wood grain is replaced with your own uniquely textured fingerprint, the front door makes the welcoming statement, "This is my house. Come in. Let me make myself at home."

Time and Space died yesterday. We already live in the absolute.
—Filippo Marinetti

24/7 OVERCLOCKED

SOSIGENES OF ALEXANDRIA, COURT ASTROLOGER TO THE EMPEROR JULIUS CAESAR, WAS HARDLY THE FIRST TO NOTICE THE DISCREPANCY BETWEEN ASTRONOMICAL TIME AND EXPERIENTIAL TIME: THE EARTH, DESPITE ITS UNDENIABLE CHARM, DOES NOT COMPLETE ITS SOLAR ROTATION IN A TIDY 365 CALENDAR DAYS BUT IS "OFF" BY APPROXIMATELY 5 HOURS, 49 MINUTES, AND 12 SECONDS. THE JULIAN CALENDAR, WHICH ADDED A DAY EVERY FOUR YEARS, SOUGHT TO RECONCILE THE CYCLES OF THE PLANETS AND THE TERRESTRIAL TIMING OF MARKET DAYS, RELIGIOUS FESTIVALS, AND MEETINGS OF THE ROMAN SENATE. IT WAS INSTITUTED IN 45 BCE, JUST IN TIME TO RECORD CAESAR'S ASSASSINATION ON THE IDES OF MARCH.

THE RELENTLESS PROGRESS OF TIMEKEEPING TECHNOLOGY SOON RENDERED THIS CORRECTION IN-ADEQUATE. AS NATURAL EXTENSIONS SUCH AS THE SUNDIAL, THE HOURGLASS, AND THE CLEPSY-DRA YIELDED TO INCREASINGLY PRECISE, SELF-CONTAINED MECHANICAL DEVICES—THE PENDULUM CLOCK, THE VERGE-AND-FOLIOT ESCAPEMENT, THE POCKET WATCH—ASTRONOMERS NOTED THAT AN ELEVEN-MINUTE DISCREPANCY REMAINED BETWEEN THE DAILY ROTATION OF THE PLANET ON ITS OWN AXIS AND ITS ANNUAL ORBIT AROUND THE SUN. IN 1582, POPE GREGORY XIII ADDED A CHRISTIAN LEAP DAY TO THE PAGAN LEAP YEAR TO BRING EARTH AND SUN, HUMAN TIME AND THE COSMOLOGICAL TIME, BACK INTO ALIGNMENT. THIS, TOO, WORKED FOR A WHILE.

RECENTLY, IN A SHOCKING ADMISSION THAT THE UNIVERSE DOES NOT GIVE A HOOT FOR HUMANS AND THEIR TIMETABLES AND APPOINTMENTS, THEIR PRODUCTION SCHEDULES AND MENSTRUAL CYCLES, A CLUSTER OF INTERNATIONAL TREATIES SET OUT TO LEGISLATE THE DURATION OF A SEC-OND. IT IS NOW DEFINED AS THE AMOUNT OF TIME IT TAKES FOR THE CESIUM-133 ATOM TO "TICK" 9,192,631,770 TIMES. WHO'S KIDDING WHOM?

THE TENSION BETWEEN CLOCK TIME AND LIVED TIME THAT TROUBLED THE ANCIENT ASTRONO-MERS HAS ONLY GOTTEN WORSE. AS OUR MEASURING DEVICES GROW EVER MORE ACCURATE, WE FIND OURSELVES PERPETUALLY "OVERCLOCKED," TO USE A TERM FAMILIAR TO EVERY COMPUTER HACKER WHO HAS RATCHETED UP A COMPONENT TO RUN AT A HIGHER CLOCK SPEED THAN IT WAS

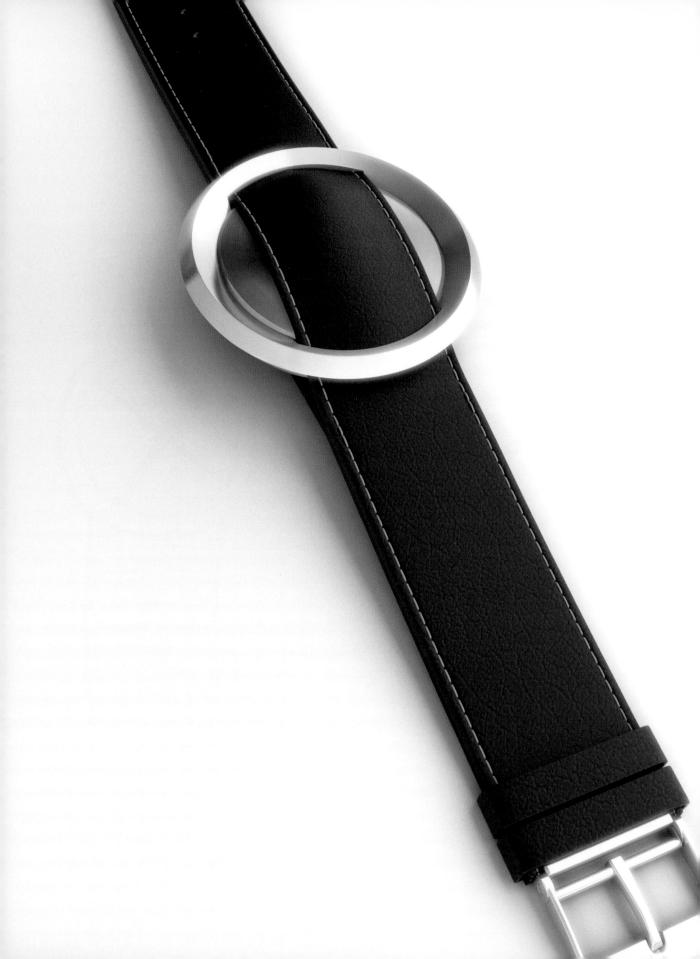

INTENDED FOR IN ORDER TO COAX HIGHER PERFORMANCE OUT OF A SYSTEM. WE DO THE SAME TO OURSELVES. WE CALIBRATE OUR LIVES ACCORDING TO TECHNICAL CAPACITY RATHER THAN HUMAN EXPERIENCE.

NONOBJECTIVE THINKING RESPONDS WITH A CABINET OF HOROLOGICAL CURIOSITIES INTENDED TO RESTORE THE BALANCE BETWEEN CLOCK TIME AND LIFE TIME. THEY INVITE US TO RETURN TO A MORE EXPANSIVE AND MORE NATURAL FIELD OF TIME, TO BE MINDFUL OF ALL THAT HAS PASSED AND ALERT TO ALL THAT REMAINS TO BE DONE, AND ALL THE WHILE TO EMBRACE THE DELIGHTS OF THE PRESENT.

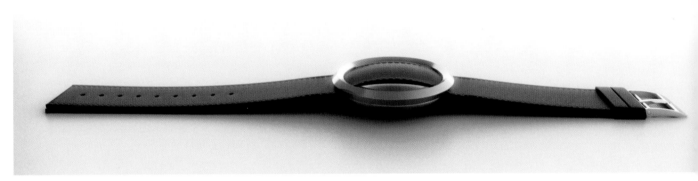

TICK-TOCK INNER CLOCK

THE DESIGN OF THIS WATCH ALLOWS FOR A COMPLETELY NEW TIMEKEEPING EXPERIENCE. LIKE MOST WATCHES, TICK-TOCK INNER CLOCK SITS ON THE WRIST. BUT RATHER THAN ASKING US TO TRANSLATE A VISUAL OR NUMERICAL CODE INTO THE TIME OF DAY, ITS RHYTHMIC TAPS AGAINST THE SKIN ALLOW US TO *FEEL* THE PASSAGE OF TIME. TICK-TOCK INNER CLOCK DEFIES THE MEANINGLESS RAGE FOR PRECISION. IT STRETCHES THE WEARER'S SENSE OF TIME, TRANSLATING TEMPORALITY INTO SUBTLE TACTILITY. IT IS "HANDS-FREE" IN THE BEST SENSE OF THE TERM. IT PLAYS WITH THE POSSIBILITY OF FEELING TIME, OF TOUCHING TIME, AND BEING TOUCHED BY TIME OVER THE COURSE OF A DAY.

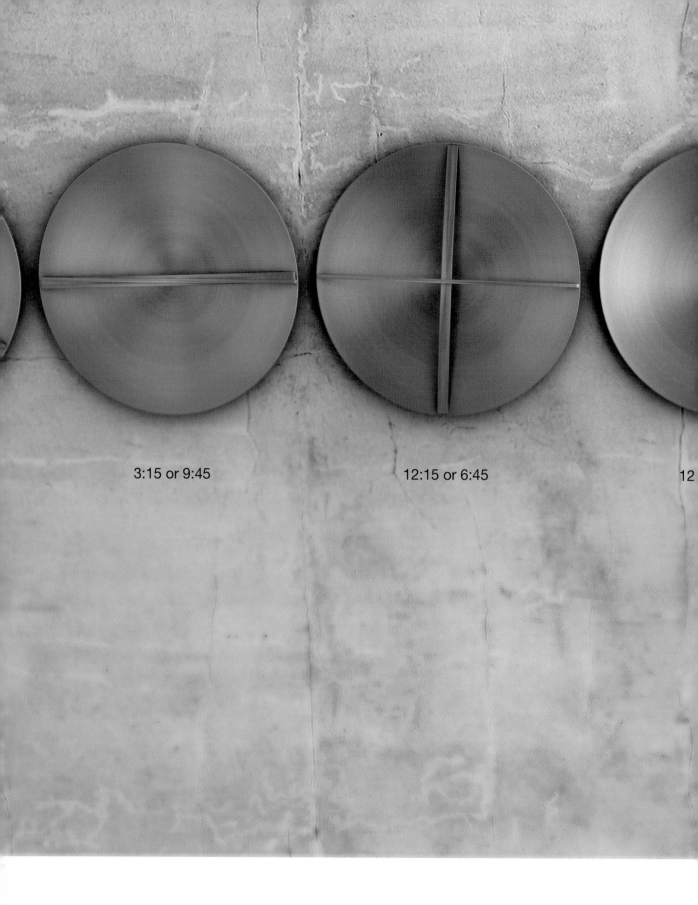

3:15 or 9:45 12:15 or 6:45 12

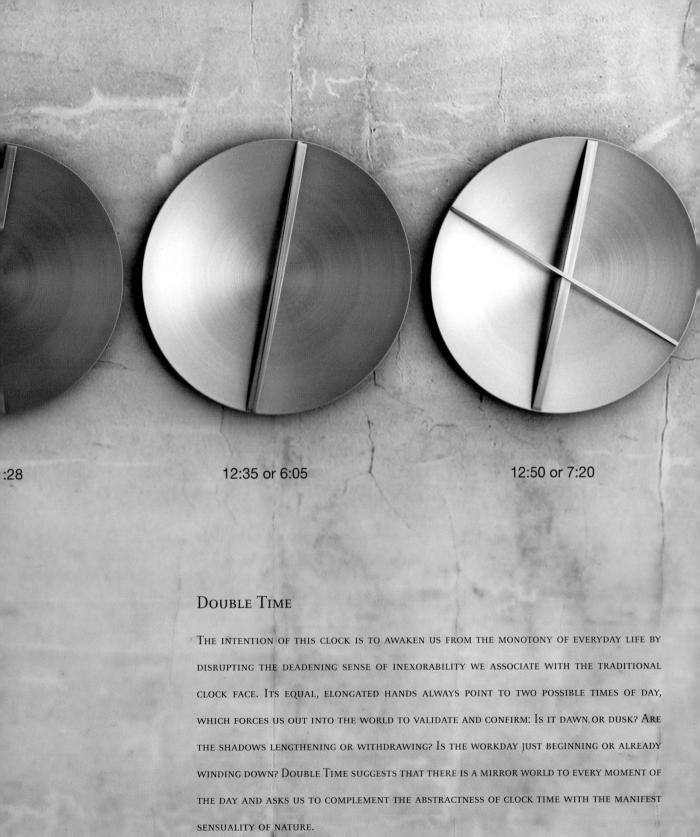

:28
12:35 or 6:05
12:50 or 7:20

Double Time

The intention of this clock is to awaken us from the monotony of everyday life by disrupting the deadening sense of inexorability we associate with the traditional clock face. Its equal, elongated hands always point to two possible times of day, which forces us out into the world to validate and confirm: Is it dawn or dusk? Are the shadows lengthening or withdrawing? Is the workday just beginning or already winding down? Double Time suggests that there is a mirror world to every moment of the day and asks us to complement the abstractness of clock time with the manifest sensuality of nature.

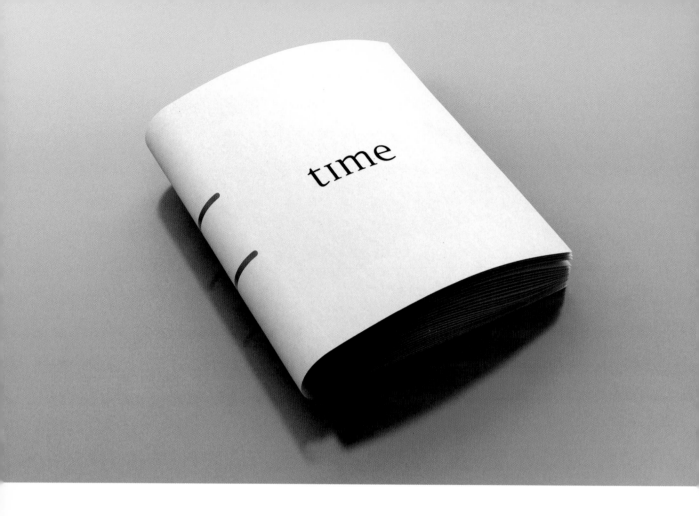

Clockbook

Most clocks are designed to tell us how much of our day is irretrievably gone, and digital clocks are even worse: they flatly announce what time it *is*, with no concern for anything but the *now*. Imagine, instead, a clock that draws us toward all that lies ahead. When we read a book, the weight of the volume constantly hints to us of the pages yet to be read. This is the idea of Clockbook. It helps us pass through time as we would pass through pages in a storybook. The paper-thin metal pages impart a completely new, anticipatory experience of time. Every day holds out the promise of a new story to tell.

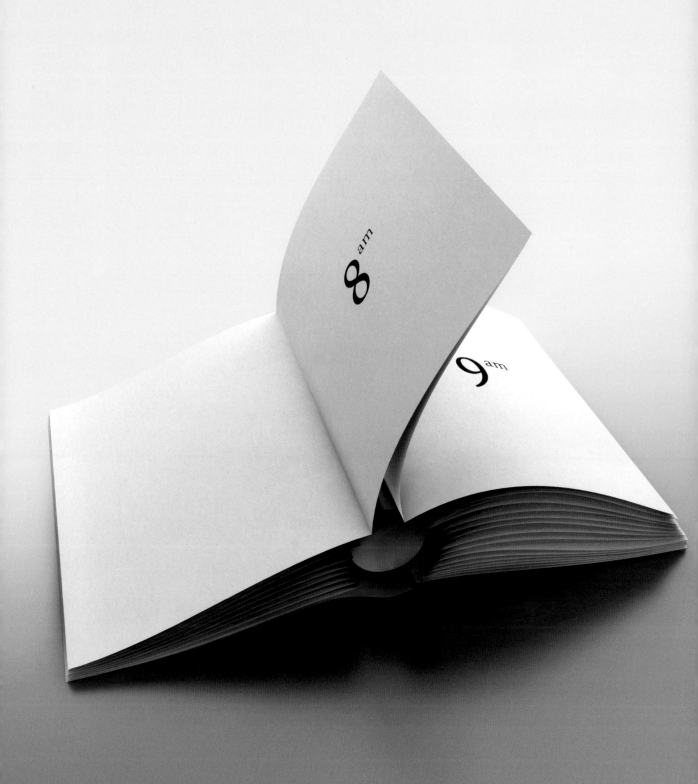

Rather than oppose the merely practical,
we must drive through to the other side.

SUPERPRACTICAL

In 1934, the young Alfred Barr, Jr., boldly placed 600 industrial, scientific, and commercial objects on display at New York's Museum of Modern Art. Some designs, he proposed, are the result of deliberate artistic intent. More intriguing—his examples included a helical bearing spring and a Vernier micrometer—are those whose innate beauty is the unintended expression of clarity, integrity, and due proportion. Barr invited a group of dignitaries to select the most beautiful objects in MOMA's landmark Machine Art exhibit, and they confirmed his thesis: aviatrix Amelia Earhart chose an industrial spring, and a steel ball bearing assembly caught the eye of Charles Richards of the Museum of Science and Technology; philosopher John Dewey meditated upon the serenely platonic form of a ship's propeller manufactured by Alcoa.

Thus began the discourse on the poetics of the practical, but it ended too soon, saddling us with an impoverished inventory of numbingly functional objects and generic interfaces. Just look at the TV aisle of your local Big Box retail store with its endless array of trivial variations on a common theme. Then move on to clocks, cameras, computers, and cooking utensils. Does the practical have to be so . . . *PRACTICAL*?

Much of this sorry state of affairs derives from the realities of business: whether we are speaking with our clients or hearing from our customers, designers are constantly told, "Whatever you do, make the interface practical." We do our best to oblige, and the results are unfailingly pragmatic, functional—and lifeless. This led us to formulate the methodology of the Superpractical.

The best analogy is jujitsu, which exploits the opponent's own energy, as contrasted with American boxing, which opposes it with countervailing force. The Superpractical reacts to the legitimate demand for practicality by extending it to its logical (and sometimes illogical) limits. Could there be a chair in which you can sit on the

SEAT, THE ARM, OR THE LEG? A TELEVISION THAT CAN BE GAZED AT, LIKE A CRYSTAL BALL, FROM EVERY ANGLE (INCLUDING LYING ON YOUR BACK, FROM BELOW)? A HOTEL IN WHICH GUESTS CAN SLEEP COMFORTABLY IN THE BAR, THE LOBBY, OR THE ELEVATOR (WITH FULL ROOM SERVICE, OF COURSE)? THE NONOBJECTIVE IMAGINATION REELS AT THE POSSIBILITIES!

OUR AIM IS TO RECOVER THE MAGIC THAT LIES BURIED WITHIN THE PRACTICAL AND EXTEND IT IN ALL DIRECTIONS. LIKE PABLO NERUDA, INTOXICATED BY HIS "CRAZY, CRAZY LOVE OF THINGS," WE HAVE SET OUT TO CAPTURE THE UNDERSTATED PURITY OF BOTTLE OPENERS AND SALT SHAKERS, TO FIND THE ESSENCE OF ALL THOSE LIGHT SWITCHES AND DOOR HANDLES THAT MODESTLY GO ABOUT THEIR BUSINESS WITHOUT CALLING ATTENTION TO THEMSELVES WHILE CONNECTING US WITH IMPORTANT PARTS OF OUR LIFE. RATHER THAN OPPOSE THE MERELY PRACTICAL, WE MUST DRIVE THROUGH TO THE OTHER SIDE: NOT THE IMPRACTICAL, BUT THE *SUPERPRACTICAL*.

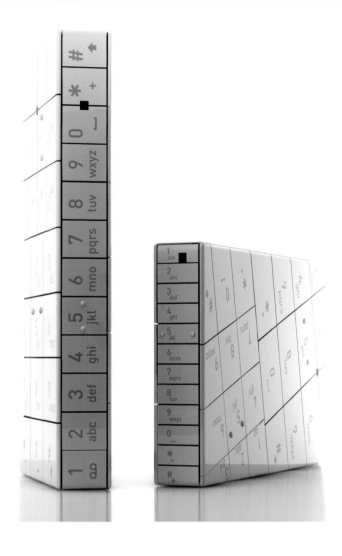

CUn5: Superpractical Cell Phone

Consumer electronics nurture dreams of pure functionality, which mostly lead to products characterized by generic features and dull practicality. This need not be the case. Why not push practicality to a higher level? A practical mobile phone will have its buttons neatly aligned for maximum legibility. A superpractical phone will array them across every possible surface so that no matter which way you grab it—upside down, in the dark, in a panic or just plain drunk—you have immediate access to a dialing surface. The first surface touched becomes active and aglow, ready for you to dial, talk, or listen, while the others lock patiently in place.

Optimum

The inventor Anthony Maglika once sued a competitor who was manufacturing shameless knockoffs of the iconic Maglite. His rival protested that since a flashlight is basically a receptacle for batteries—an aluminum tube that lights up—the shape is objectively determined and cannot be anyone's proprietary right. The courts dealt swiftly with this hollow defense, but we wish to take it seriously. Optimum is a flashlight with the most basic form possible, the exact shape of the batteries it contains. Form does not simply follow function; it honors it, obeys it, and submits humbly before it. Its nondesign purifies the relation between object and user. Form disappears into function, and function is all that is left, simple and beautiful.

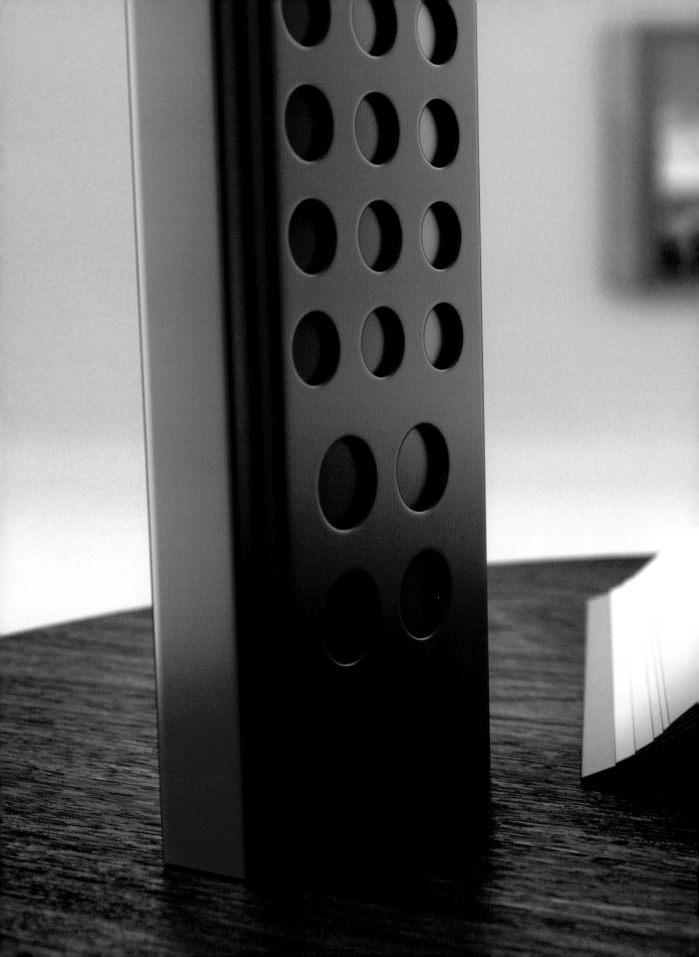

Remote Control Book

Our tendency, in these fraught technological times, is to surround ourselves with gadgets. This is fine, except that they have become so complex (and we have become so lazy) that we now need second-order gadgets to control our first-order gadgets. These nondescript controllers proliferate on shelves and in drawers, mocking us with arbitrary configurations of buttons that no one understands. The Remote Control Book restores an analog experience to a digital device. Each supple page controls a different appliance, so that changing channels on a television or cranking up the volume on a favorite CD is as natural as turning the creamy pages of a well-bound book.

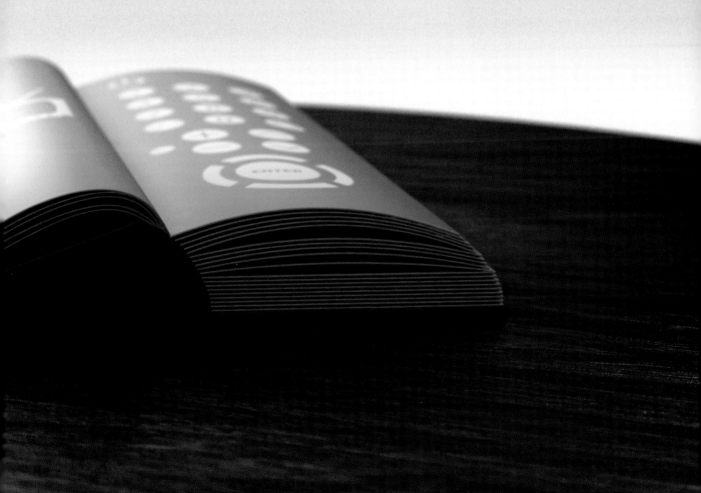

I Love You Helmet

What better way to show your love than to climb aboard your chopper with your partner and share headspace as you cruise the highways and byways of your imagination? Comment discretely on the curious townsfolk you pass, even as they comment curiously on you. Point out historic landmarks and recall to each other stories about the events that transpired. Whisper your most romantic thoughts, despite the roar of the engine that pulses beneath you, as the moon rises over a mountain lake. Two heads, two hearts, one helmet.

SHARE — WHAT ARE THE THINGS
SHARE?

- EXPERIENCE
- CONTENT
- BED
- FUN
- MEMORIES
- MEN
- RECEPIE
- HOUSE
- TUNE
- VISION
- SMILES

- SOCIETY
- VALUES
- CONFLICTS

The philosophy of the Nonobject is the antidote to
the reality of the nonperson.

PERSONAL

The greatest thing about humans—and the source of *all* of our problems—is that each of us is different. By contrast, all the great social innovations of modern times, from administrative bureaucracies to Scholastic Aptitude Tests, assume that with a little prodding we can be stuffed into a standard behavioral mold. It was a well-intentioned, even idealistic thought in its time. Indeed, the problem is not so much that it isn't true as that it is self-fulfilling: the uniform modernist subject became the "mass man" of Ortega y Gasset and the "authoritarian personality" of Adorno.

Every architecture student has heard the story of Pruitt-Igoe, the ill-starred public housing project flung up into the sky by the city of St. Louis in 1954 and brought crashing down to earth twenty years later. The 11-story, 33-tower complex was intended to warehouse the urban poor in segregated blocks named for an African American fighter pilot and a white former congressman, but almost from the day they were occupied the buildings fell into decay. On a balmy spring afternoon in 1972, in the most celebrated insult to the homogenizing social aspirations of the Modern Movement, the entire complex was dynamited. People want to be treated equal, not alike.

The same holds true of our products, as anyone who has been stuffed into the middle seat of a transcontinental airliner can attest. For fifty years an unholy trinity of mass production, mass media, and mass culture conspired to persuade us that deep down inside we all want the same things. American industrial designers tried to soften the hard edge of European rationalism by slathering things over with tailfins, wood grain appliqué, and logos, but it never really worked. Not only are we different, we are inconstant. Our tastes fluctuate. Our needs and desires change over time. We contradict ourselves from one day to the next. We are ill served by fickle objects that grope for the lowest common denominator.

THE PERSONAL LINE OF NONOBJECTS CHALLENGES THE NOTION THAT HUMANS, IN THEIR INFINITE VARIETY, MUST SUBMIT TO THE INFLEXIBLE DEMANDS OF FIXED AND STABLE FORMS. IT INVITES US TO EXPLORE THE OUTER LIMITS OF INDIVIDUATION, NOT JUST AS IT AFFECTS OUR PHYSICAL EXPERIENCE BUT OUR INTELLECTUAL AND EMOTIONAL BEING AS WELL. THIS IS A FAR CRY FROM THE TRIVIAL NOTION OF ORDERING UP A "MASS-CUSTOMIZED" CAR OR SHIRT OR HOLIDAY CRUISE, WHICH AMOUNT TO NOTHING MORE THAN A COMBINATION OF STANDARDIZED FEATURES. PERSONAL NONOBJECTS DO NOT SIMPLY GIVE US A WIDER CHOICE OF STANDARDIZED COMMODITIES TO CHOOSE FROM. THEY CARRY THE PHYSICAL MARKS OF OUR HANDS AND FEET, THE EMOTIONAL MARKS OF OUR EVANESCENT MOODS, THE SPIRITUAL MARKS OF OUR DESIRE TO BE AT HOME IN A WORLD WE HAVE MADE.

AS USUAL, IT WAS THE POET WHO GOT IT RIGHT. WITH APOLOGIES TO JOHN DONNE, "NEVER SEND TO KNOW FOR WHOM THE BELL CURVE TOLLS: IT TOLLS FOR THEE."

XXX TOILET

THE XXX TOILET GIVES NEW MEANING TO AN OLD PHRASE: "FLUSHED WITH PRIDE." IT ASSERTS THE DIGNITY OF ALL OF OUR FUNCTIONS AND CHALLENGES THE INVIDIOUS HIERARCHIES THAT PLACE THE BRAIN ABOVE THE HEART, THE HEART ABOVE THE BODY. WHERE IS IT WRITTEN THAT MIND MUST HOLD FORTH OVER MATTER? WHY IS IT THAT WE LAVISH SUCH ATTENTION TO THE FRONT END OF THE ALIMENTARY CANAL AND IGNORE THE NETHER REGIONS? WHAT NEW ECOLOGY WOULD FOLLOW IF WE WERE INDUCED TO THINK NOT JUST ABOUT WHAT WE TAKE FROM NATURE, BUT WHAT WE RETURN TO IT? THE XXX TOILET IS PERHAPS THE CLEAREST EXAMPLE OF WHAT HAPPENS WHEN WE PRESS AN IDEA INTO AN UNFAMILIAR AND UNCOMFORTABLE SPACE.

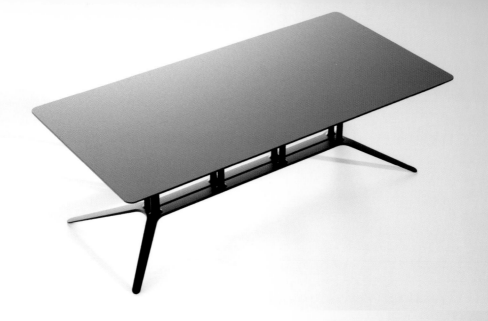

Dictator

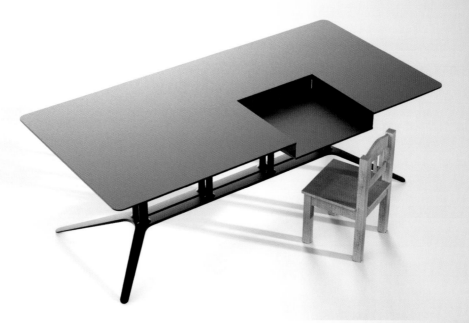

Compromise

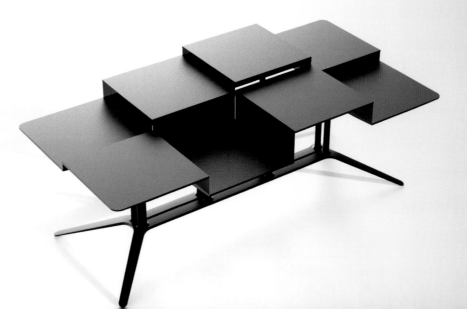

Democracy

Athenian Table

Ancient Athens careened between democracy and dictatorship, the rule of the many and the rule of the few, and the Athenian Table does the same. In its dictatorial mode—barely distinguishable from a normal table—it imposes a common height upon every guest. Too short? Sit on a telephone book. Too tall? Slouch. Too handicapped? Too bad. In its democratic mode, however, every surface adjusts to the stature of the person seated in front of it. The democratic table reminds us that our objects, like our officials, should be accountable. It casts off the tyranny of sameness, the oligarchy of uniformity, the absolutism of evenhandedness. One diner, one vote.

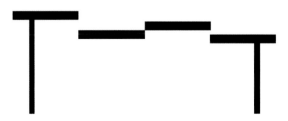

iEat Diet Spoon

This utensil system combines two of our most morbid fascinations. On the one hand is our obsession with "closing the information loop" (the display on a Prius that informs us of our driving habits; the Nike+ sensor system that captures performance data and downloads it to a runner's iPod). On the other is our obsession with eating and dieting. With the iEat Diet cutlery system the dieter decides in advance how much is too much. When the spoon, fork, or knife reaches its capacity, a preprogrammed signal is sent to a sensor embedded within a hinge and the utensil simply collapses. It's hard to believe that nobody thought of this before.

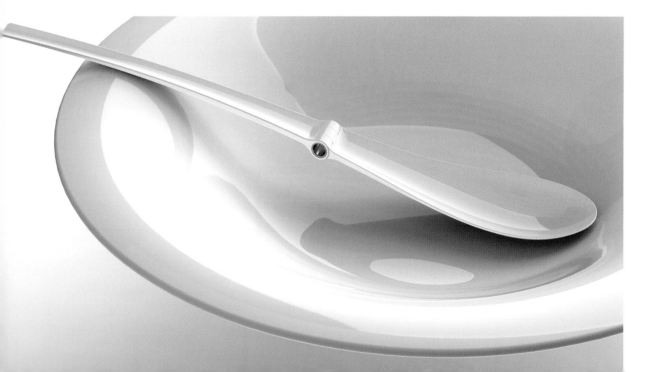

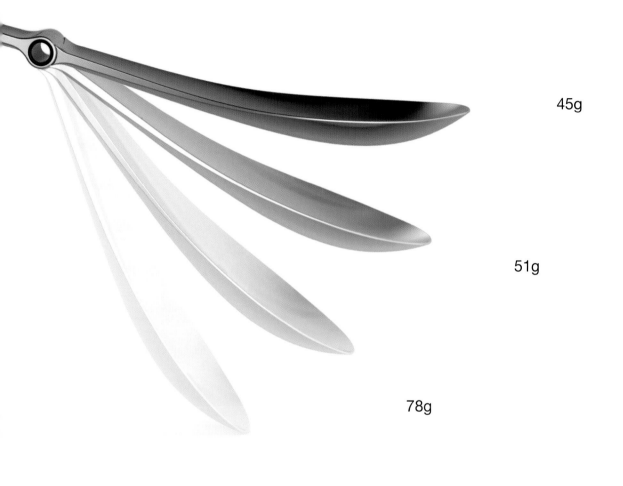

45g

51g

78g

93g

BeCycle

Philosophers throughout time have puzzled over the dualities of human nature and how to transcend them: Mind and Body, Self and Other, the Ego and the Id. The BeCycle extends this exploration to the dualities of things. It proposes a new approach to design that reveals inner workings and outer appearance simultaneously. For decades industrial designers have artfully concealed the mechanical guts of their products under a finished surface. The BeCycle repudiates this duality and the invidious hierarchy on which it is based. It is a prototype of the totally honest Nonobject of the future that expresses everything and privileges nothing.

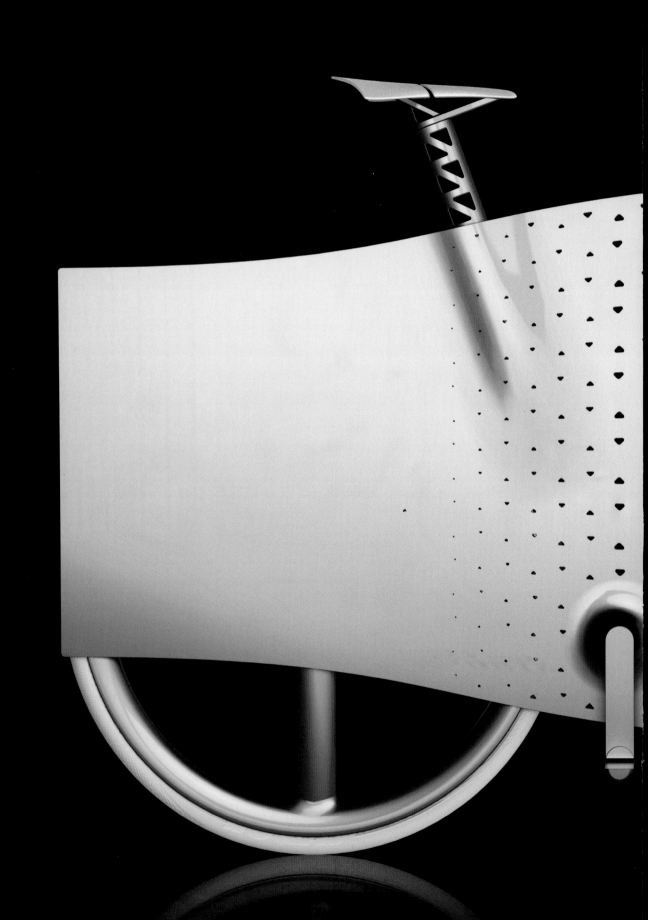

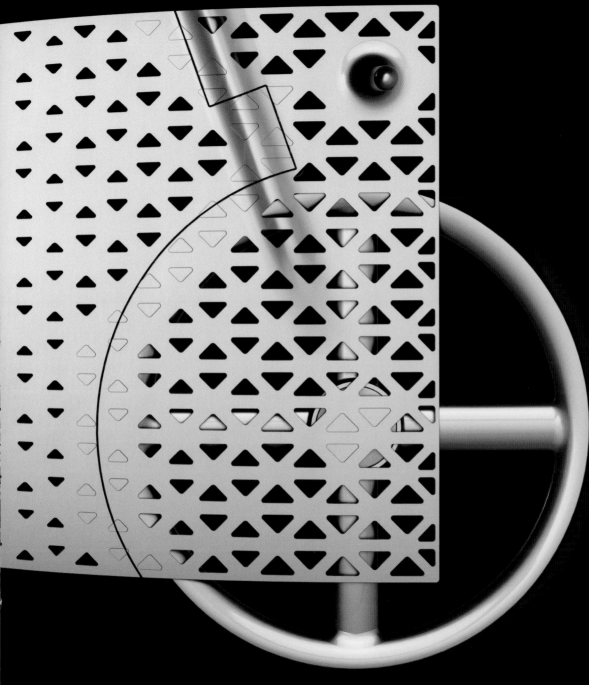

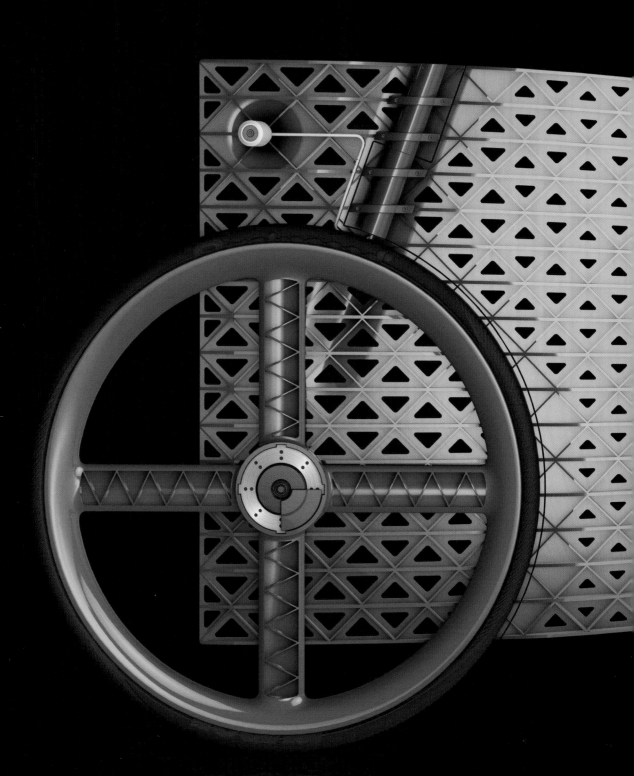

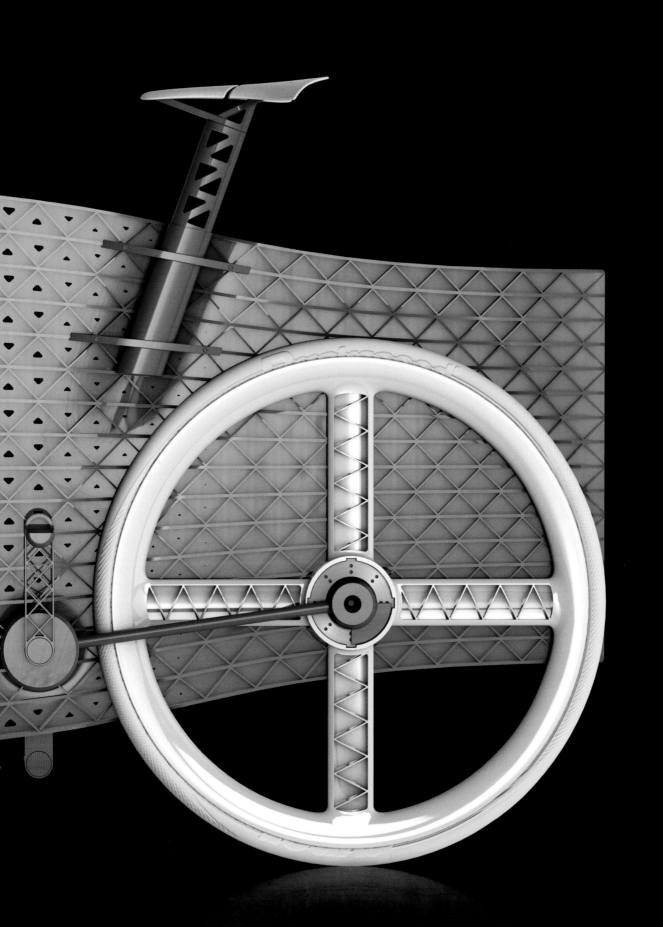

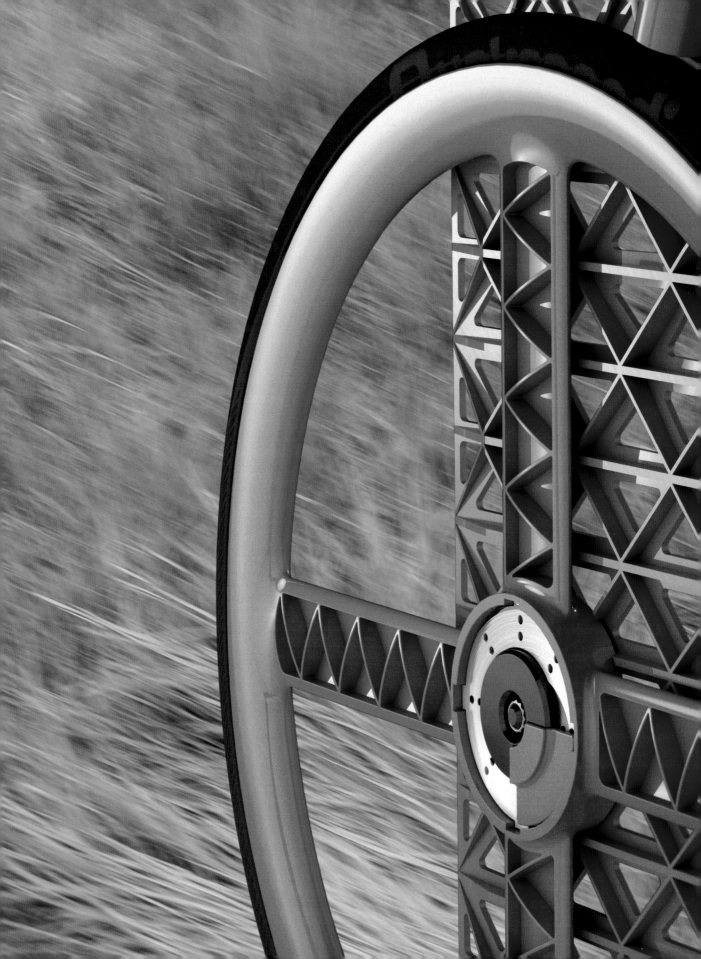

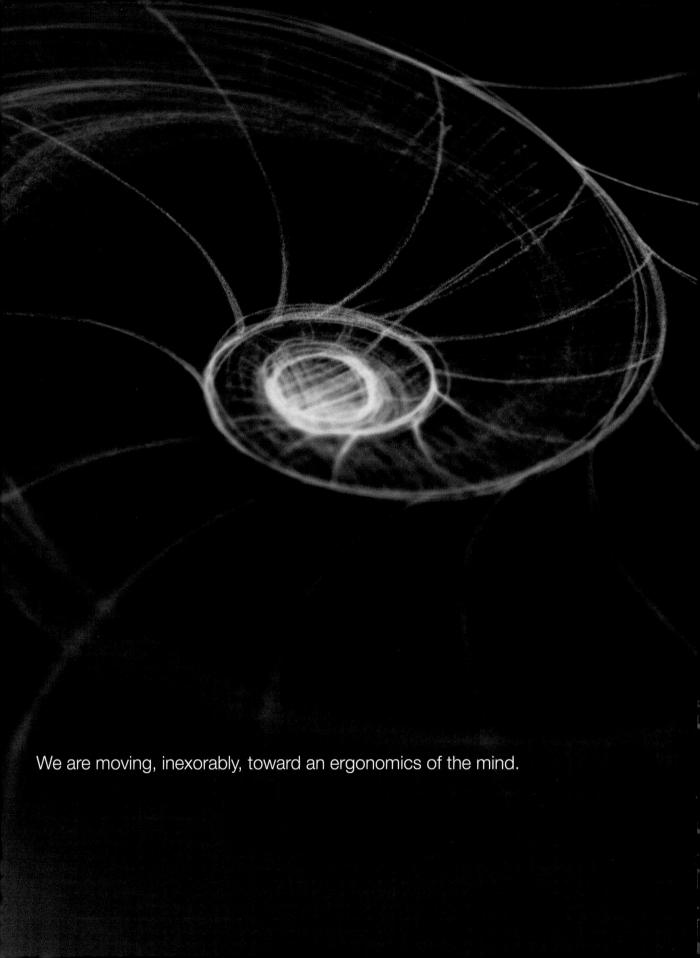

We are moving, inexorably, toward an ergonomics of the mind.

INNER

At the beginning of his charming memoir, *Designing for People* (1955), Henry Dreyfuss proudly introduced two of the key employees in the industrial designer's office: "They are part of our staff," he explained, "and they dictate every line we draw." "Joe" and "Josephine" (and their children) were anthropometric stick figures that told the designer where to locate the dial on a thermostat, how much pressure needs to be applied to a brake pedal, or the correct angle of a typewriter keyboard. Style and subjectivity would henceforth be subordinate to empirical data. The physiology of the user, rather than the taste of the designer, would be the final arbiter of form. Armed with statistical tables and usability studies and a degree of anatomical detail that approached the pornographic, we learned how to design the cabs of forklifts, the handles of garden tools, and eventually the home pages of Yahoo! and Google and Facebook.

There is mounting evidence, however, that we have entered, today, a post-Cartesian, postergonomic world in which mind and body, head and hand, are being reunited, and experience is returning to the center of our concerns. Classical ergonomics took seriously the claims of the human body in all of its physical and physiological complexity. What about the ergonomics of the mind? The Inner collection of Nonobjects takes account of the whole person.

Inner Nonobjects seek to reawaken the dynamic interaction between our artifacts and ourselves by exploring a single principle: we take an external detail and move it to the interior, for no other reason than to see what will happen. Overcoats have buttons on the exterior; what happens if we move them to the interior? Cars have their turn signals on the outside; what happens if we move them to the inside? Books wear their titles on their covers; what would it feel like to browse the shelves of a library in which the spines were bare and the titles faced inward? How will it alter

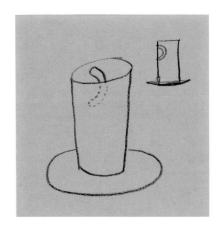

OUR PERCEPTION? HOW WILL IT CHANGE OUR BEHAVIOR? HOW WOULD IT CHANGE THE PACE, RHYTHM, OR PATTERNS OF OUR DAILY ROUTINES? WE BELIEVE THAT THE EFFECT WOULD BE TO TURN OUR LIVES FROM A SEQUENCE OF PREDICTABLE MOTIONS AND FOREGONE CONCLUSIONS TO A CONTINUOUS EXPERIMENT.

WE LEAVE IT TO OUR FRIENDS AT NASA AND THE JET PROPULSION LABORATORY TO WORRY ABOUT OUTER SPACE. THESE NONOBJECTS EXPLORE INNER SPACE, THE SPACE BETWEEN THE OBJECT AND THE SELF.

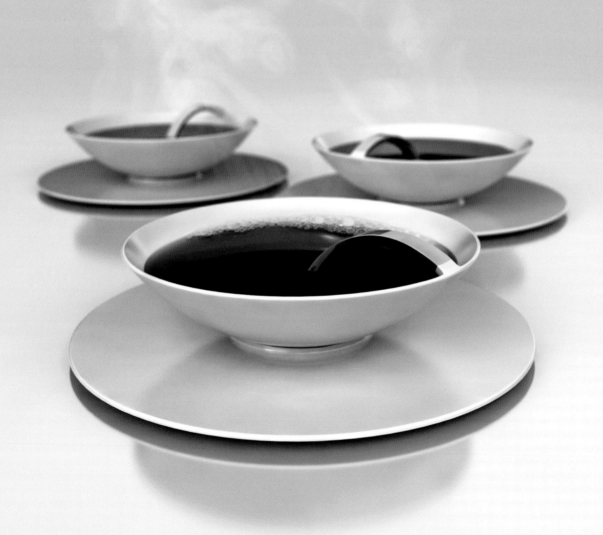

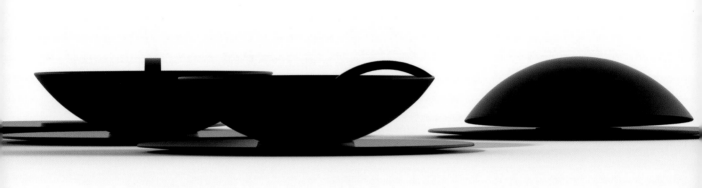

Innerware

This concept began simply enough as a series of sketches. What happens if we shift the placement of the handle from the outside to the inside? In the case of the coffee cup, the effect was to alter the whole script—the balance of form and function changed, but so also did the play of perception and experience, and the drama of the coffee cup played out in new and exciting ways. Astonishingly, usability even improved, and before we knew it, dinnerware became Innerware. What other handles might we move?

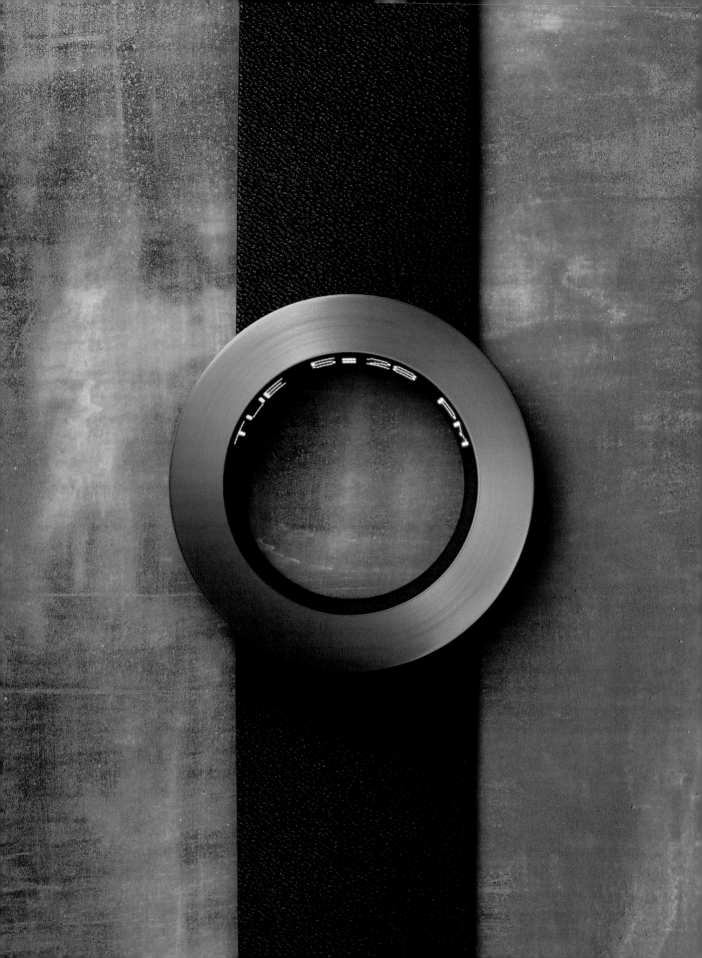

INNER TIME

THE ARRIVAL OF THE MICROPROCESSOR DID NOT SOUND THE DEATH KNELL FOR THE SWISS WATCH-MAKING INDUSTRY AS IT DID FOR CHEMICAL PHOTOGRAPHY. THIS IS BECAUSE WE WEAR WATCHES AS PERSONAL JEWELRY, NOT AS IMPERSONAL CHRONOMETERS. INNER TIME, A WATCH WITH A HEART BUT NO FACE, TAKES THE INTIMATE SIDE OF TIMEKEEPING ONE STEP FURTHER BY FREEING US FROM THE EXTERNAL STATUS OF BRAND. IT PLACES A PIECE OF JEWELRY ON THE WRIST THAT DISCRETELY REVEALS THE TIME OF DAY WHEN YOU PASS YOUR FINGER ACROSS THE FACELESS FACE. DYNAMIC DIGITAL INFORMATION IS DISPLAYED ALONG A GLOSSY BLACK INNER RING, FOR YOUR EYES ONLY, AND ONLY WHEN YOU WISH TO SEE IT.

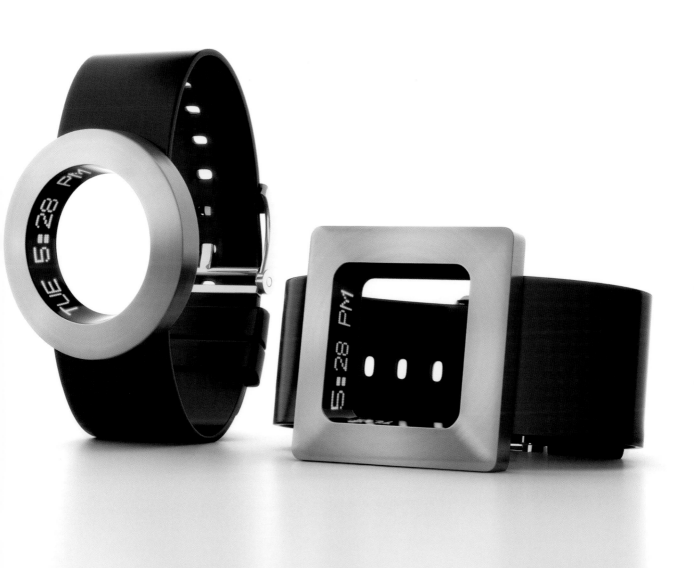

Unglasses

Ever since Sam Foster began selling his tinted lenses on the Boardwalk in Atlantic City, sunglasses have functioned on a multiplicity of levels: they enhance the glamour of actors; they heighten the performance of athletes; they assert the authority of the traffic cop; they intrigue; they alienate; they intimidate. Such is the power of the tinted lens that when Elvis or Marilyn peered out at the world from behind their Foster Grants, they could define a trend for a generation. Unglasses do the opposite. They are not style defining, but style *defying*. Turning the gaze inward, they repudiate the outer world. Unglasses are the ultimate sunglasses.

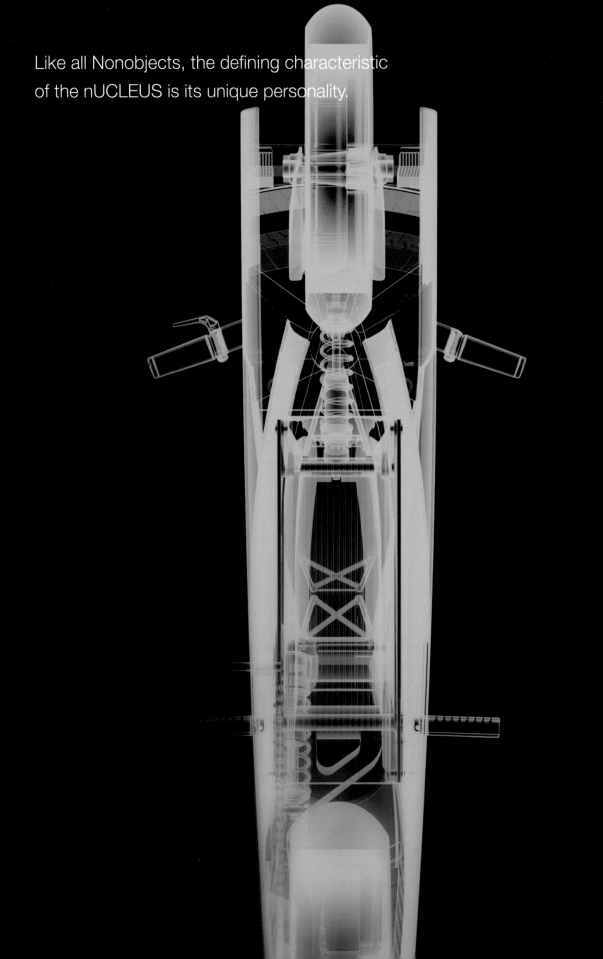

Like all Nonobjects, the defining characteristic
of the nUCLEUS is its unique personality.

POSTINTUITIVE

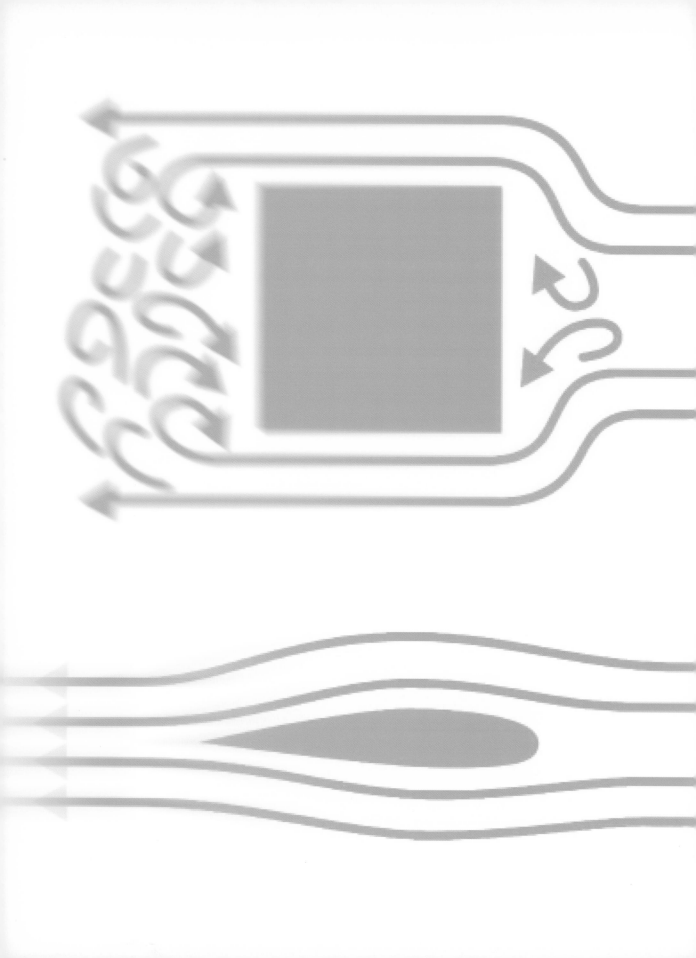

nUCLEUS Motorcycle

The nUCLEUS Motorcycle represents our deepest research into the essence of the Nonobject. Like all the other exercises presented here, it asks us to start by forgetting everything we know—about motorcycles, to be sure, but also about physics, engineering, manufacturing, and design. Implicitly, it challenges us to think about why we are beholden to the ideas of the past, even as we charge, often blindly, into the future.

nUCLEUS Motorcyle does not pay homage to the cruisers of the 1950s or bow down before the phony symbolism of the streamline. It's a motorcycle built on the nonobjective principle of "square against air." The resultant form is nonintuitive, antagonistic, and profoundly challenging. But despite its apparent indifference to aerodynamic styling, the nUCLEUS is actually amazingly fast. The shell consists of two fierce blades that enclose the rider and slice through the air like a pair of daggers.

The most striking feature of the nUCLEUS, however, is not its speed, its exquisite balance, or its uncanny responsiveness. Like all Nonobjects, the defining characteristic is its unique personality. Like a stallion, it rears itself up on its hind legs when it is ready for action; it returns, kneeling, to its locked position while at rest.

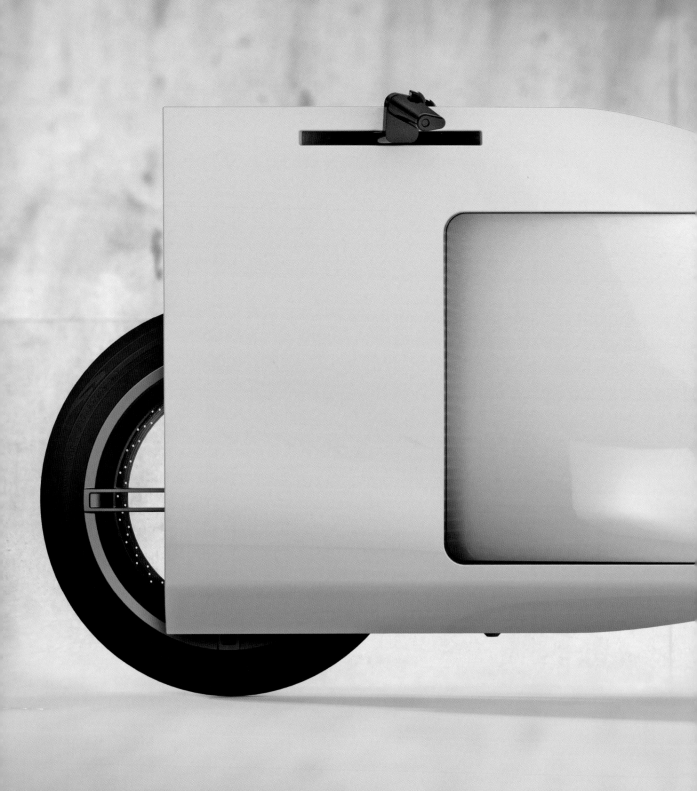

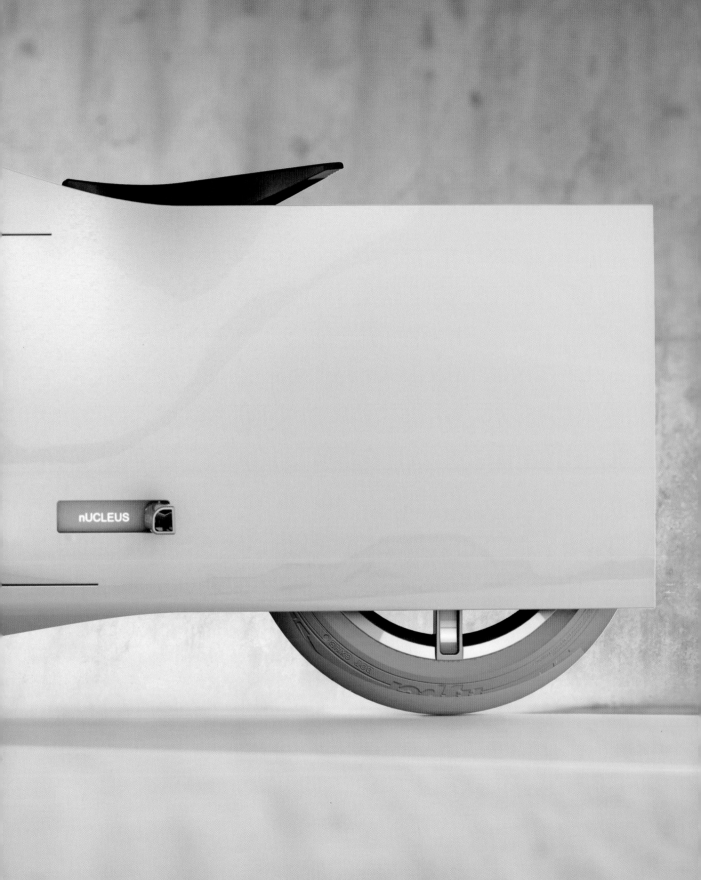

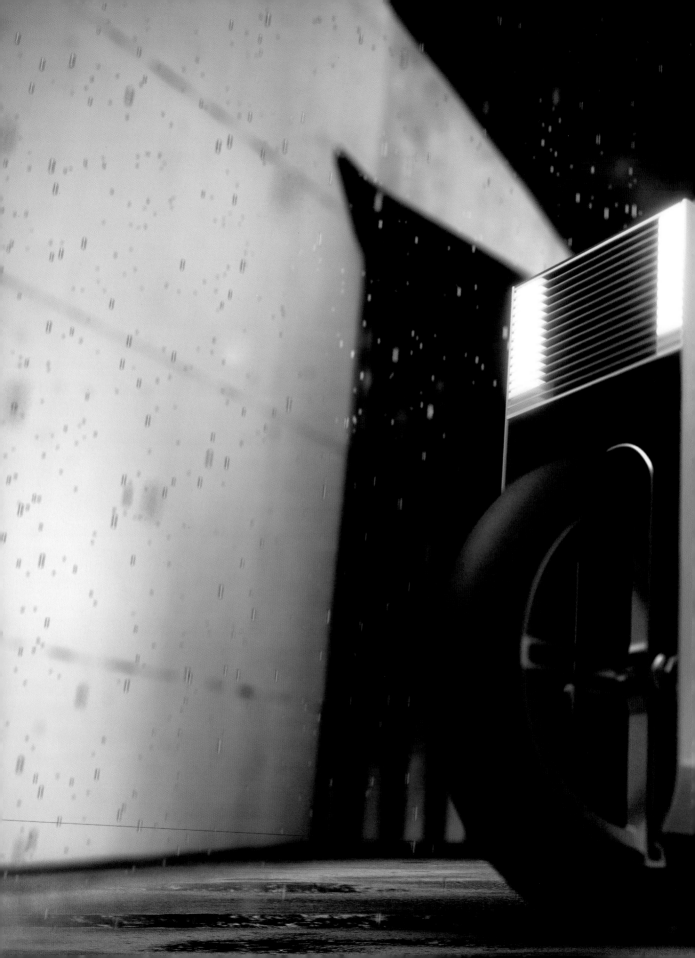

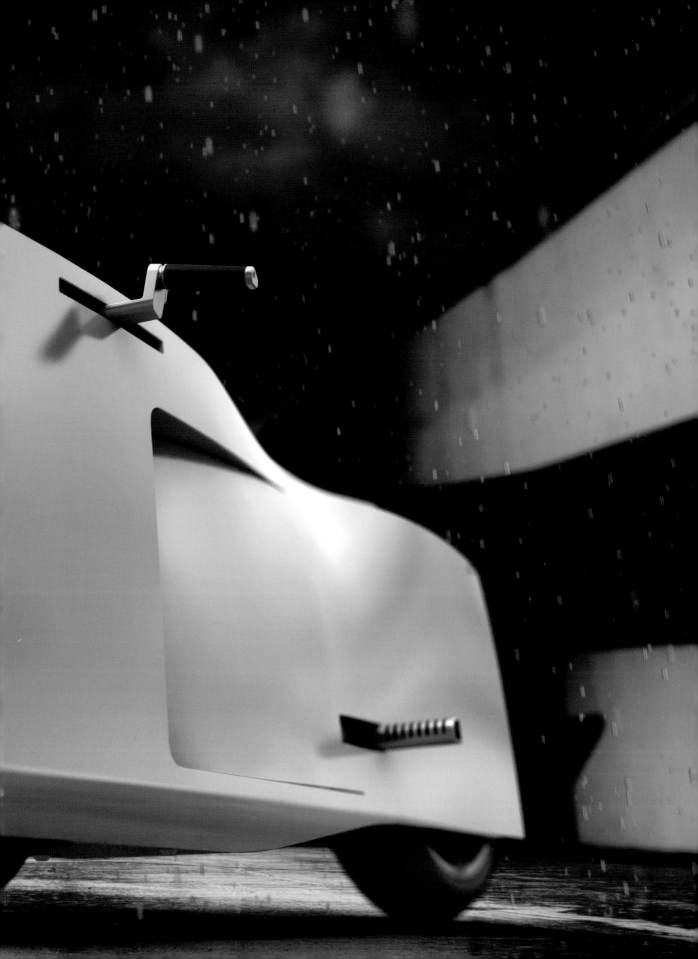

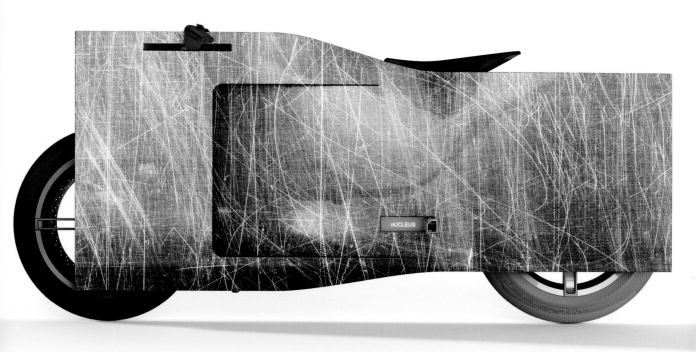

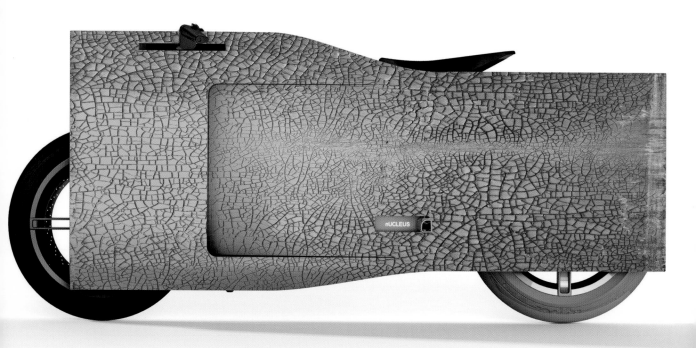

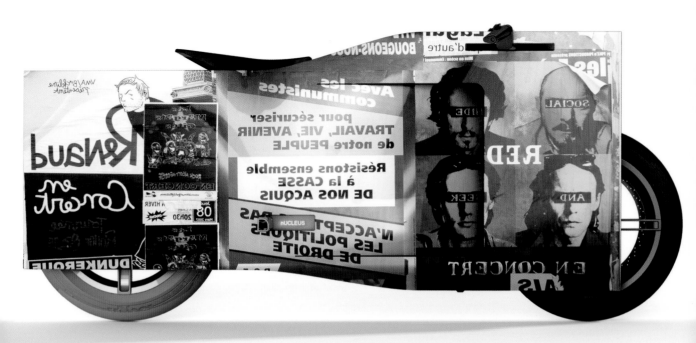

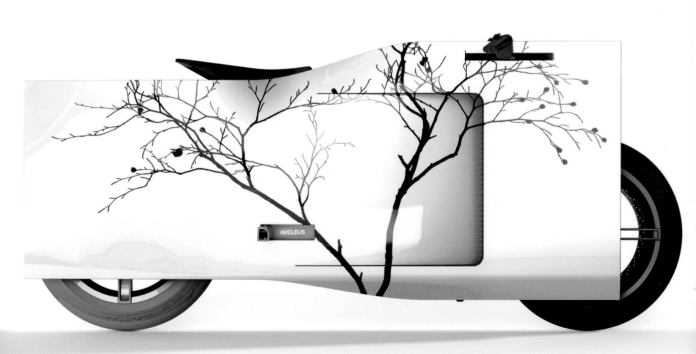

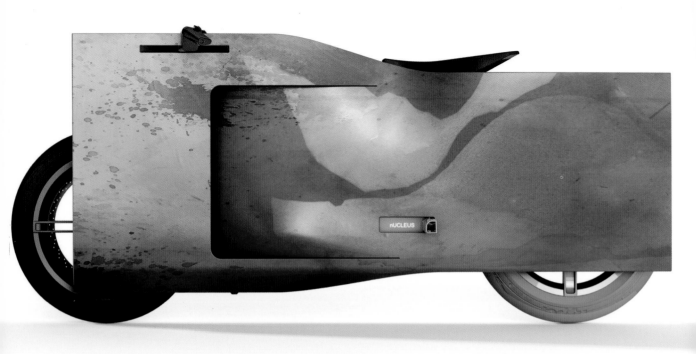

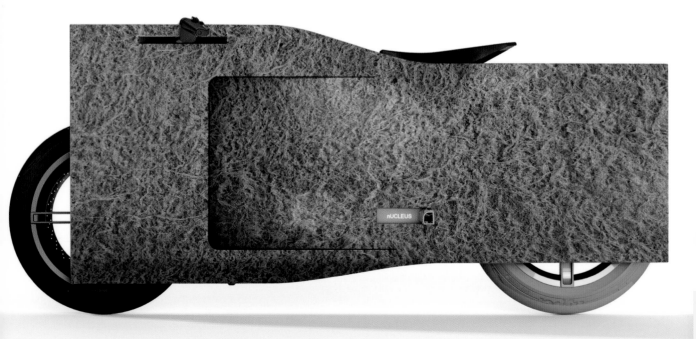

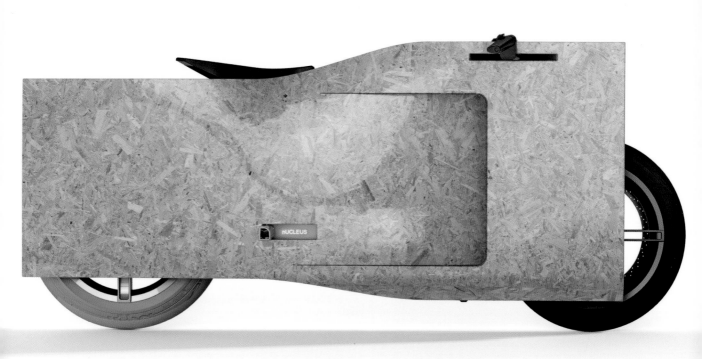

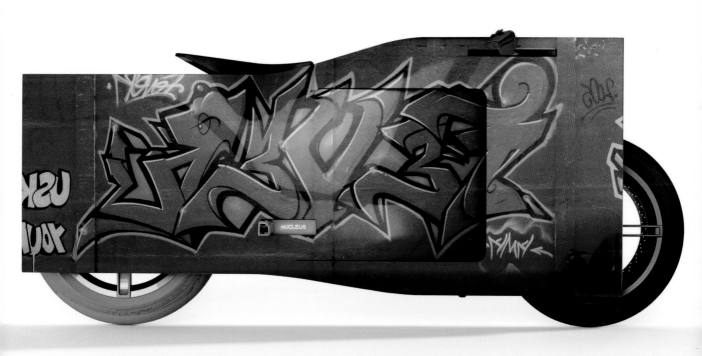

Creation happens in seconds.

SKETCHOLOGY

THESE SKETCHES, TOGETHER WITH THOSE THAT INTRODUCE EACH OF THE CHAPTERS THAT PRE-CEDE THEM, ARE FROM THE NOTEBOOK THAT BRANKO LUKIĆ CARRIES WITH HIM AT ALL TIMES. THEY REVEAL SOMETHING OF HIS DESIGN PROCESS AND THE SOURCES OF HIS INSPIRATION, AND THEY PLACE HIM IN VERY GOOD COMPANY. LEONARDO'S UNCANNY DRAWINGS OF HELICOPTERS AND PONTOON BRIDGES AND TRANSMISSION BELTS STILL IGNITE OUR IMAGINATIONS FIVE CENTU-RIES LATER. JOSEPH PAXTON'S BACK-OF-THE-ENVELOPE DOODLE OF AN ENORMOUS GREENHOUSE, A "CRYSTAL PALACE," WAS THE ORIGIN OF THE MOST IMPORTANT BUILDING OF THE 19TH CENTURY, AND LE CORBUSIER'S CARTOON OF A "MASS-PRODUCTION HOUSE," AS REGULAR AND REPEATABLE AS A DOMINO, LAID BARE THE SKIN-AND-BONES OF THE WHOLE PROGRAM OF TWENTIETH-CENTURY ARCHITECTURE. "I CANNOT SO WELL SET IT FORTH IN WORDS," CONFESSED THE INVENTOR GUIDO DA VIVEGANO IN 1335, "AS I SEE IT IN MY MIND'S EYE. BUT THE PICTURE WILL SHOW IT."

LIKE OTHER DESIGN METHODOLOGIES, THE CREATION OF A NONOBJECT ENTAILS RIGOROUS FIELD-WORK, ALTHOUGH IN BRANKO'S CASE THIS RARELY TAKES THE FORM OF MARKET RESEARCH, FOCUS GROUPS, MAIL-IN SURVEYS, OR MALL INTERCEPTS. AS HIS SKETCHBOOK REVEALS, THERE IS PLENTY TO BE LEARNED FROM LOOKING INSIDE.

DURING THE EARLIEST PHASES OF THE DESIGN PROCESS THE DESIGNER'S MIND TURNS INTO AN INTRICATE CAD MACHINE AS IT MANIPULATES VARIABLES, ROTATES AND SCALES AN IDEA, AND GRADUALLY FORMS AN OPINION ABOUT ITS VIABILITY. YOUNG IDEAS ARE FRAGILE, AND BRANKO FINDS THAT THEY CAN BE EASILY DAMAGED BY THE SHARP POINT OF A PENCIL OR THE SHEER PRO-CESSING POWER OF A COMPUTER. HE PREFERS TO CONTEMPLATE A CONCEPT IN ITS INTELLECTUAL PURITY, AND ONLY ONCE IT HAS BEGUN TO CONGEAL DOES HE CAPTURE IT IN HIS SKETCHBOOK AND THEN DEVELOP IT IN DIGITAL AND THEN TANGIBLE FORM.

"CREATION HAPPENS IN SECONDS," BRANKO ONCE HEARD HARTMUT ESSLINGER TELL A CLIENT. THESE SKETCHES, THE EARLIEST VISUAL TRACES OF THE IDEAS THAT FORM THE BASIS OF THIS BOOK, SPILLED ONTO PAPER IN A VERY SHORT TIME. THEY MAY PROVIDE THE READER WITH AN INSIGHT INTO THE JOY-FUL IMAGINATION AND THE INTENSE INTELLECTUAL LABOR THAT PRECEDED THEM.

SUPER ČAŠA ②

SIDE FRONT

~~ZENSW~~
ADAPTER
ZA
POSSIBLE

NI USB
ADAPTER
A ČIŠĆU

~~GOJI~~ SSTASIŠĆE ČAŠU
NA STOLU

4/1LI 1.
18 PUPČEŠ
ZA TEČNOST

YES

PRINT PRINT PRINT
THE SIZE of
A ENTRY
DOOR, BECOMES
SOMETHING ELSE,
NOT WOODGRAIN,
RATHER VERY
PERSONAL

VODA KNJIGA

ZA SVAKI DEN
PO JEDNA
KNJIGA

1,5 LITRA DO
2 LITRA

DUČNA
DOZA

PONEDELJAK
UTORAK
SREDA
ČETU
PETAK
SUBOTA
NEDELJA

ZA VRATA

UJSTA

ŠOBICA "LU"

SHOLLITZA
SHOLITZA
SHOWLITZA

TWEAKED OUT

IN-OUT PEN

IN OUT

TRAFFIC LIGHT

ZELENO
CRVENO
ŽUTO

CAM

FRONT BA

LENS

TOP

⑨

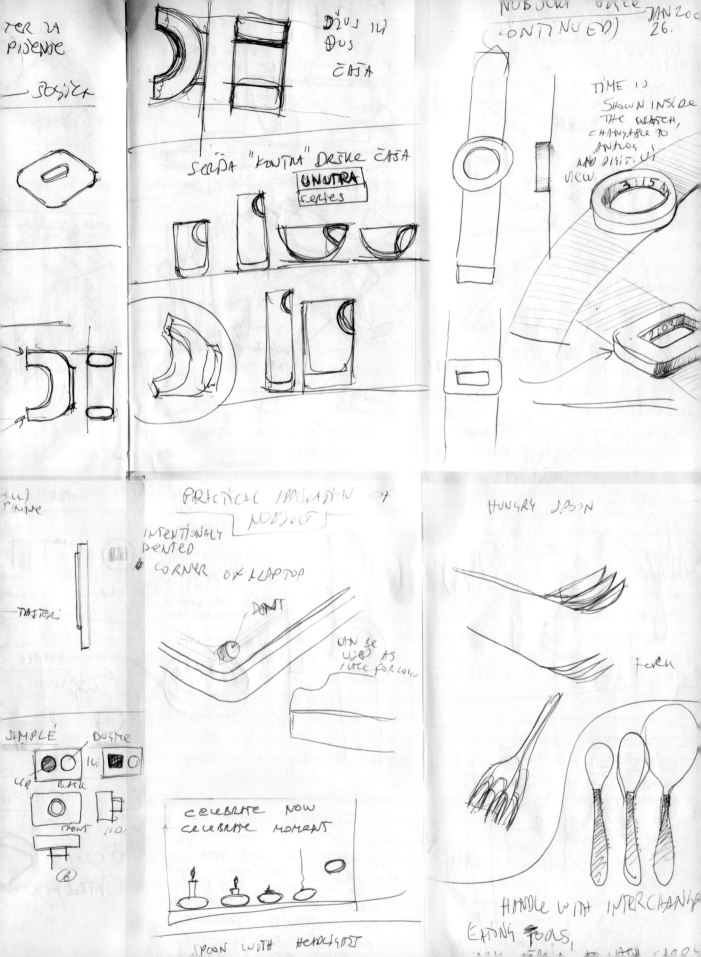

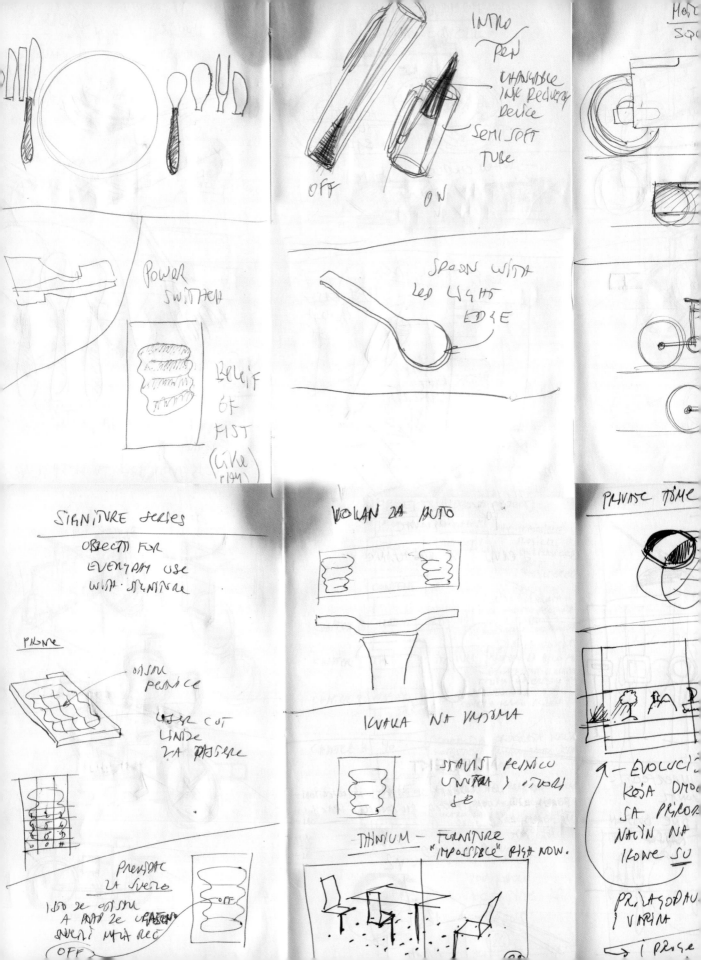

INTRO
PEN

CHANGABLE
INK REFILL
DEVICE

SEMI SOFT
TUBE

OFF ON

POWER
SWITCH

BELIEF
OF
FIST
(LIKE
PART)

SPOON WITH
LED LIGHT
EDGE

SIGNITURE SERIES

OBJECTS FOR
EVERYDAY USE
WITH SIGNITURE

PLATE

ORSON
PERNICE

USER CUT
LINDE
ZA PISSERE

PREMSDAT
ZA SVETLO

150 ZE OPSTU
A MAP ZE URISSU
SVETI MITA REC

OFF

VOLAN ZA AUTO

IKVAKA NA VRSIMA

STAVIT PEJNICU
UNUTRA J OTVORI
SE

TITANIUM — FURNITURE
"IMPOSSIBLE" RIGH NOW.

PRIVATE TIME

— EVOLUCI
KOJA OMOD
SA PRIROD
NAČIN NA
IKONE SU

PRILAGODJAU
J VARNA
J PRISE

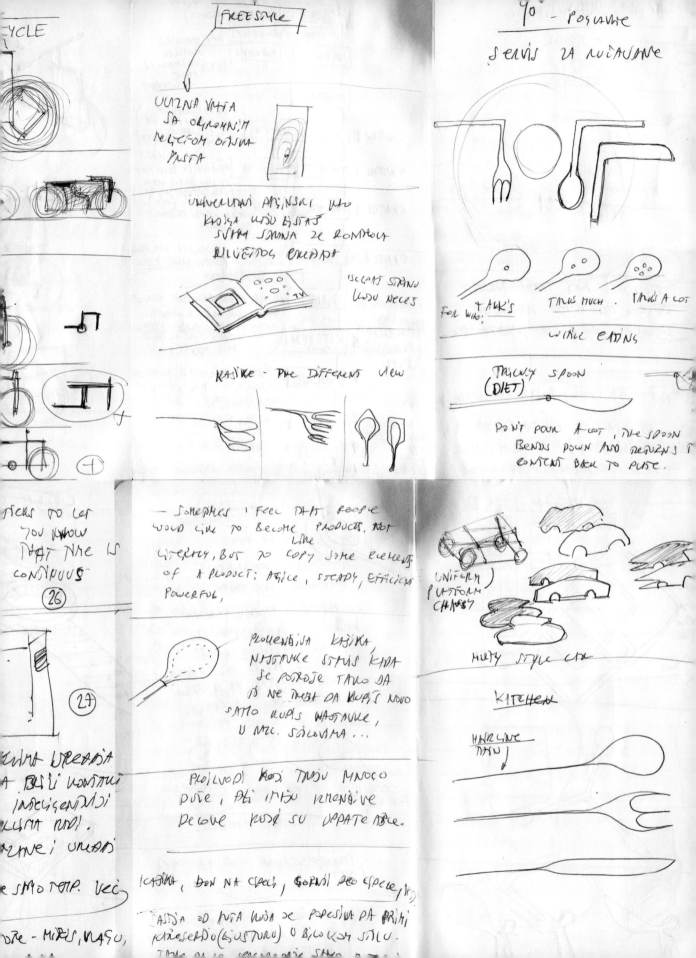

YCLE

FREESTYLE

UUIZNA VRATA
SA ORIGINALNIM
RELICIFOM OGNJA
PASTA

UNIVERLNI PRISINSKI UI
KAŠIKA NOŽ LIŠTAJ
SVAKI SAKRNA SE ROMBOU
DIVEŠOS EMARA

ISCRTAJ STRANU
KOJU NEĆEŠ

KAŠIKE - PRE DIFFERENT VIEW

90° - POSUĐE

SERVIS ZA RUČAVANJE

FOR WHO? TAKS MUCH. TAKES A LOT

WHILE EATING

TRICKY SPOON
(DIET)

DON'T POUR A LOT, THE SPOON
BENDS DOWN AND RETURNS T
CONTENT BACK TO PLATE.

TICKS TO LET
YOU KNOW
THAT THE IS
CONTINUOUS

26

27

- SOMETIMES I FEEL THAT PEOPLE
WOULD LIKE TO BECOME PRODUCTS. NOT
LIKE
LITERLY, BUT TO COPY SOME ELEMENTS
OF A PRODUCT: AGILE, STEADY, EFFICIENT
POWERFUL,

PLOMENBILA KAŠIKA,
NASTAVKE STATUS KADA
SE POKROJE TAKO DA
TO NE TREBA DA KUPIŠ NOVO
SAMO KUPIŠ NASTAVKE,
U NRL SOLOVIMA...

PROIZVOD KOJI TRAJU MNOGO
PUTE, ALI IMAJU IZMENJIVE
DELOVE KOJI SU UPPATENTABLE.

UNIFORM
PLATFORM
CHASSY

MULTY STYLE CAR

KITCHEN

HAIRLINE
THIN

KAŠIKA, DON NA CRECI, GORNJI DEO ESPERE,

JASDJA ZD RVTA KOJA SE POPESIVA DA PRIMI
KREJERDJO (BIJISEDRU) U BILO KOM STILU.

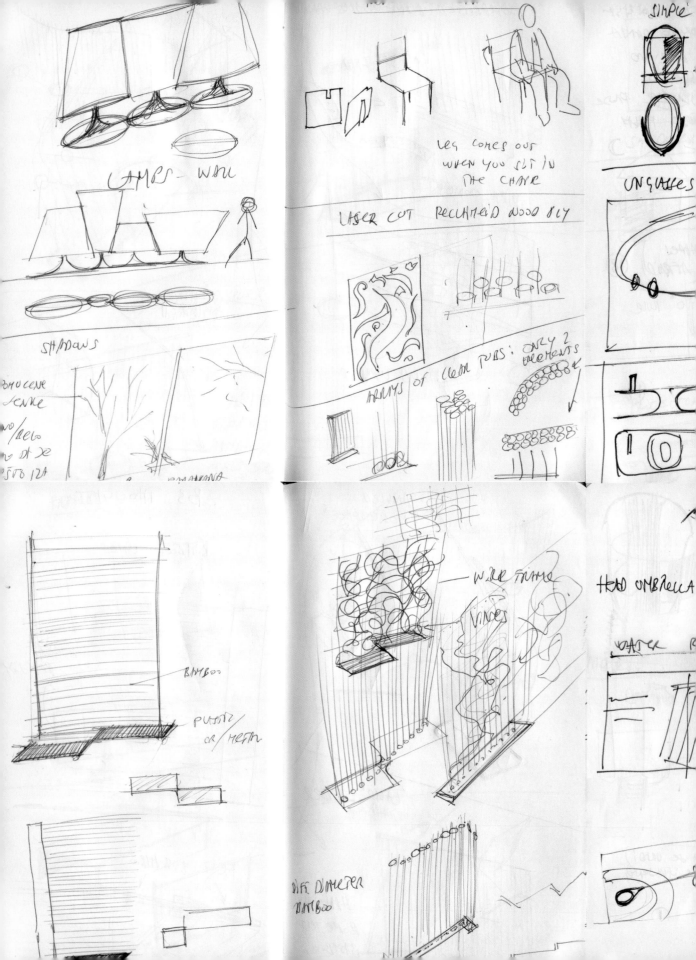

LAMPS - WALL

SHADOWS

LEG COMES OUT
WHEN YOU SIT IN
THE CHAIR

LASER CUT RECLAIMED WOOD SLY

ARRAYS of CLEAR TUBES: ONLY 2
ELEMENTS

SIMPLE

UNGLASSES

BAMBOO

PLASTIC
OR/METAL

WIRE FRAME

VINES

DIFF DIAMETER
BAMBOO

HEAD UMBRELLA

NLY" 90° STAPLE

STAPLE

← STAPLER

OF

DISPLAY IS SUCKED

DIFFERENTLY FROM COMMON LOCATION, ON THE BOTTOM, UNDER THE KEYPAD, JUST FOR FUN.

AS YOU GO WITH THE TIP OF YOUR FINGER CLOSE TO SQUARE OPENING THE LED BACKLIT NUMBER LIGHTS UP SO YOU KNOW WHAT NUMBER YOU DID

NAPKIN SET
UTENSILS

NON OBJECT — NOV 21 2005.
KARIM AND TOSHO
MUZUMI
THE YESTERDAY'S PARADIGM
(TODAY)

$10 $8.75 $6.19 $4.59

HOW CAN WE IMPROVE THIS AND PROVIDE REAL EXPERIENCES
PEOPLE WITH
ON ALL LEVELS?

$1.99

PARTIAL EXPERIENCES

PARTIAL
EXPERIENCES PART 2.

1 2 3

48

COCTAIL NIGHT 49

DIET

COUN...

ESPRESS...

PREMIUM

Branko Lukić is the originator and creator of the Nonobject design philosophy.

Branko is founder and principal of Nonobject Studio in Palo Alto, California (www.nonobject. com), which provides design innovation solutions and strategic consulting services to established companies, nonprofit organizations, and startups worldwide. He holds many patents and has won numerous awards. He teaches in the Product Design Program at Stanford University and has lectured at universities, conferences, and design exhibitions around the world.

Barry Kātz helped to articulate the philosophy of the Nonobject.

Barry is Professor of Design at the California College of the Arts, Consulting Professor at Stanford University, and Fellow at IDEO, Inc. He is the author, with Tim Brown, of *Change By Design: How Design Thinking can Transform Organizations and Inspire Innovation*, and *Tectonic Shift: The Unstable History of Silicon Valley Design*, to be published by the MIT Press.